PORTSMOUTH PUBS

STEVE WALLIS

AMBERLEY

First published 2017

Amberley Publishing
The Hill, Stroud
Gloucestershire, GL5 4EP

www.amberley-books.com

Copyright © Steve Wallis, 2017
Maps contain Ornance Survey data.
Crown Copyright and database right, 2015

The right of Steve Wallis to be identified as
the Authors of this work has been asserted in
accordance with the Copyrights, Designs and
Patents Act 1988.

ISBN 978 1 4456 5989 3 (print)
ISBN 978 1 4456 5990 9 (ebook)

British Library Cataloguing in Publication Data.
A catalogue record for this book is available from
the British Library.

Origination by Amberley Publishing.
Printed in the UK.

Contents

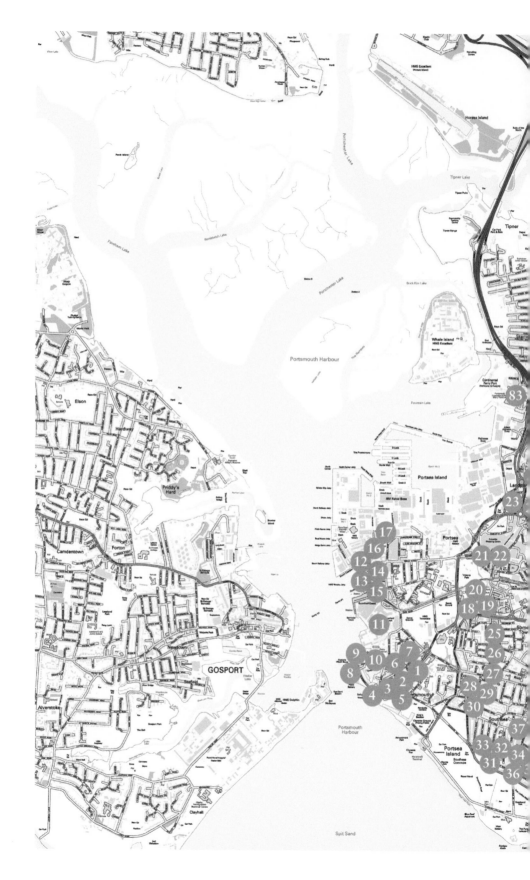

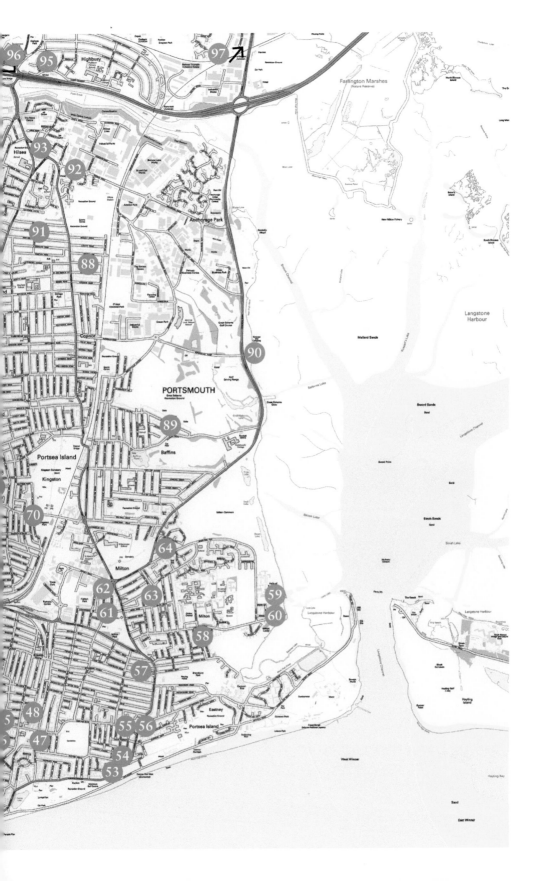

Key

61. Milton Arms
62. Brewers Arms
63. The Meon Valley
64. Good Companion
65. Froddington Arms
66. The John Jacques
67. The Electric Arms
68. Trafalgar Arms
69. The Jameson Arms
70. The Battle of Minden
71. The Florist
72. The George & Dragon
73. The BQ
74. The Blue Anchor
75. The Tap
76. The Grapes
77. The Sir John Baker
78. Thatchers
79. The Clarence
80. The Fountain

81. The Royal
82. Admiral Drake
83. The Ship & Castle
84. The Derby Tavern
85. The Portland
86. Mother Shipton
87. Green Posts
88. The Golden Hind
89. The Baffins
90. Great Salterns
91. The Phoenix
92. Toby Carvery
93. The Coach & Horses
94. The Harbour Lights
95. The Portsbridge
96. The Red Lion Hotel
97. The Sunshine
98. The George Inn
99. The Churchillian

Introduction

Portsmouth boasts a wide variety of pubs that enhance the character of this fascinating port city. Many have historic and literary associations as well as stories of their own to tell, such as the origins of their names.

Most of the older ones can be found in and around Old Portsmouth. These include the survivors of the numerous pubs that once clustered around the dockyards, providing food and drink for naval personnel and other seafarers. Others date from the expansion of the city beyond the old defences and became focal points for new communities. It is not just the older ones that are worth investigating – even the newest can have characters of their own.

The aim of this book is to look at those pubs that still function as such, of which Portsmouth still has a good and thriving number. I have also included a few pubs that have been converted to other uses where these are similar to the original one and where recognisable pub features can still be seen. Some that were currently closed but appeared likely to reopen in the near future are also included.

There is also plenty of evidence of lost pubs around the city – I have mentioned some in passing here where they illustrate a particular point. The losses have been due to wartime bombing, being within an area that was redeveloped on a large scale, or just closing through having insufficient trade.

And when we are looking at pubs, much credit must go to the architects who designed them. In Portsmouth, Arthur Edward Cogswell (1858–1934) deserves a particular mention. He was active in building Portsmouth hostelries from the 1880s to the 1930s and worked well into his seventies. He designed a great deal of pubs as well as other local buildings, and he showed a lot of variety in their design, so he clearly he did not get complacent, or bored of his job! Another architect who worked on a fair few hostelries around the same time was A. H. Bone, who was also one of the six men who founded Portsmouth Football Club in 1898.

I have aimed to include examples of the every type of pub, old and new, in Portsmouth, and to cover the whole of the city, but I must emphasise that this is only a selection – the fact that a pub is not included here should not be taken as a criticism of it.

Inside, pubs often have features that are worth hunting out, and their layouts can tell us a great deal about changing social fashions and how pubs have adapted in different ways in order to survive.

Which leads me into the question – what is a pub? If we get nostalgic and think back to the 'good old days', a pub was somewhere you went to buy one or more drinks, which were usually alcoholic and most commonly beer. In many cases, if you wanted to eat at the same time you were limited to a packet of crisps or the like. Today, pubs have adapted to changing lifestyles or simply to survive, so that many are more like restaurants where you can buy alcoholic drinks to go with your meal, and there is also a blurring between pubs and wine bars and similar establishments. To avoid complications here, I have adopted the policy that if it looks like a pub to me, it can be included.

Conversions have often involved the renaming of pubs. As examples in this book will show, renaming is not just a modern practice, and though people who have loved a pub for many years often feel that a name change has destroyed a piece of local history, it has helped some premises to survive, albeit generally in a different guise.

Whether old or new, large or small or just plain quirky, its pubs enrich an exploration of Portsmouth and help to tell the history of the city.

Old Portsmouth and Spice Island

We start our tour of the city's pubs in what is now called Old Portsmouth, but which for most of its existence was simply 'Portsmouth', since the town's defences marked the boundary between the urban area and what was largely countryside.

The town would have had alehouses soon after it was founded in the late twelfth century, which then later served the local people and visiting sailors with refreshment. The number of travellers passing through the port would have encouraged the development of inns, which offered accommodation as well. We might think that pubs of the Middle Ages were like most of those of the early twentieth century – serving customers who were mostly male with alcoholic drinks only – but they generally catered for everyone and served food, like most do today.

The local brewing industry was then given a boost when the new royal dockyard was constructed in 1495 under instructions from Henry VII. The king had brewhouses constructed in Portsmouth, then leased them to private individuals on condition that they would return to royal control in the event of war. The names of five of these were recorded thirty years later: the Anchor, the Dragon, the Lion, the Rose and the White Hart. We might think that the last thing any king wanted was more beer being available to his troops in wartime, but brewing in Tudor times tended to produce beers and ales of much less strength than today. Brewing was effectively a way of sterilising drinking water, which would usually be contaminated otherwise, and the products were a way of adding to a person's calorie intake.

Whenever brewing in Portsmouth is mentioned, the name of Brickwoods comes immediately to mind for many people, but up until around a century ago many pubs brewed their own beer on the premises (and we think microbreweries are a modern innovation!).

The central feature of Old Portsmouth is the High Street, so we begin there, working our way down from the landward end by Portsmouth Grammar School. We actually get almost halfway along the street before we find our first pub, the Duke of Buckingham, on our right.

The Duke of Buckingham

Though the present structure only dates from a rebuild in 1968, there has been a pub on this site at least since the eighteenth century. At that time it was called the Green Dragon, then it was renamed the Cambridge Tavern in the 1850s. Someone here in the 1920s had a good eye for the growing tourist trade, for at that time the name was again changed to the Duke of Buckingham. This linked it to the site on the other side of street where an assassination took place.

George Villiers was born in 1592. He rose quickly in status at the court of James I from his first visit in 1614 to being made the first Duke of Buckingham in 1623, possibly because he was the king's lover. His meteoric rise was not matched by his abilities, and he led an unsuccessful campaign in France during one of England's many wars with that country.

The duke was staying at a house in Portsmouth High Street on 23 August 1628. As he left that morning, he was stabbed to death by one John Felton, who had been a captain in the army that had fought under the duke in France. Felton had personal grievances about unreceived backpay and a lack of promotion, and it is possible he was also suffering from what we now recognise as post-traumatic stress disorder.

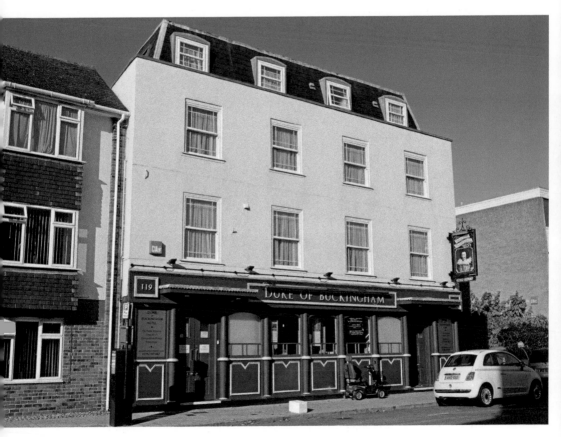

The Duke of Buckingham.

After the killing a crowd naturally gathered, and Felton did not run but instead announced to the crowd that it was his work. This seems irrational, but Felton may have had good grounds for thinking that he would be acclaimed a hero because of the duke's unpopularity. Nevertheless, he was arrested, and later tried and hung in London. Felton's body was brought back to Portsmouth to be put on display as a warning to others, but in rather an ironic twist, it was treated with respect by the locals, rather than despised as the authorities had hoped.

The house where the duke was staying on the fateful day can still be seen a little further back towards the grammar school on the opposite side of the road. At the time of the murder it was the home of one Captain John Mason, who went on to found the state of New Hampshire in the United States, but earlier it had been an inn or tavern called The Spotted Dog. The duke's military career, albeit not a very successful one, makes this the first of many Portsmouth establishments with names that commemorate people with military and naval connections.

The location of a famous pub, on the opposite side of the street a little further towards the harbour, should be mentioned here. This is The George Hotel, where Admiral Horatio Nelson supposedly spent his last night ashore before leaving England for the last time as he set off on the campaign that led to his great victory at the Battle of Trafalgar. In reality Nelson only reached the hotel at about 6 a.m. on the morning of Saturday 14 September 1805 and had to set off for HMS *Victory* out in the Solent shortly after a hurried breakfast and a couple of meetings. However, Nelson had stayed here several times before. The building, like many others in central Portsmouth, was destroyed in a German air raid on the night of 10–11 January 1941.

The Oldest Pub?

Continuing down the High Street we come to Portsmouth Cathedral, across from which is The Dolphin. This advertises itself as 'Portsmouth's Oldest Pub'. The building itself is thought to date from the seventeenth or eighteenth century, and there is a record of it being given a licence for all time by Charles I, who reigned from 1625–49 (he spent most of the 1640s fighting the Civil War, so it was probably earlier than this that he granted the licence). Even if the present building was constructed after this, it may well have had a predecessor. Apparently the pub that the king licenced was not called The Dolphin – it has had this name for only a couple of hundred years, being known as The Maidenhead before this.

I guess the claim may need to be qualified by the statement that it is 'Old Portsmouth's Oldest Surviving Pub'. As we have already seen, there were pubs here before the reign of Charles I. I also wonder if some of the village pubs that were swallowed up by Portsmouth's later expansion might be older. The Milton Arms in Milton comes to mind here, for instance.

'The Dolphin' is not simply a good nautical name. Dolphins have been seen as good luck symbols by sailors for centuries, to the extent that they were thought to protect ships during storms. So naming a pub after one would give it lots of pleasant associations for sailors, which would do no harm in encouraging them to come inside.

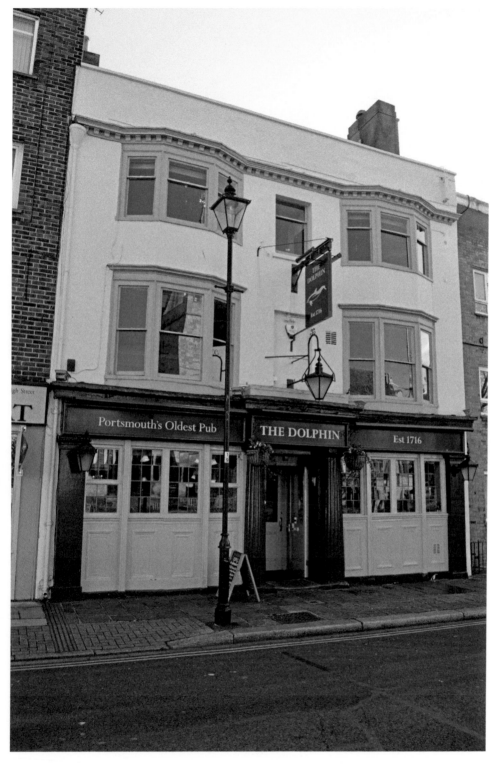

The Dolphin proudly proclaims itself to be 'Portsmouth's Oldest Pub'.

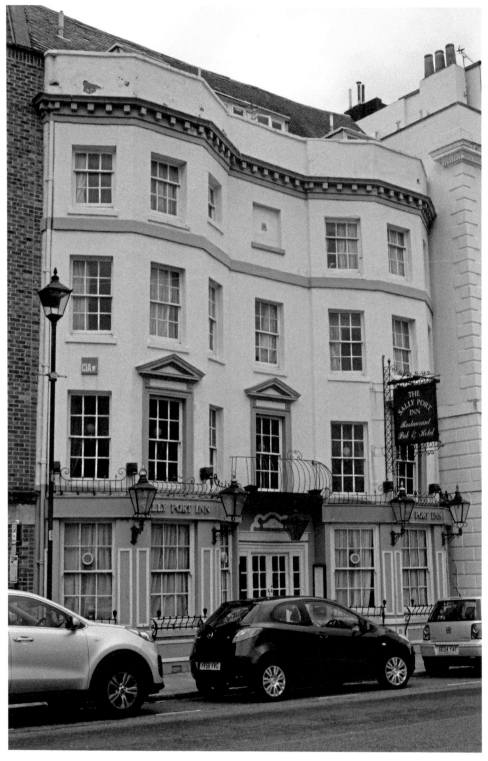

The Sally Port Hotel, due to reopen in 2018.

The Sally Port Hotel

On the same side of the road and just past the cathedral, we find the Sally Port Hotel. At the time of writing it is closed for extensive renovations and due to reopen in 2018.

The establishment takes its name from the nearby Sallyport in the section of Portsmouth's defences at the bottom of the High Street. Such a feature was a gate through which the defenders of a castle or other fortification could make a 'sally' or charge for a surprise attack on a besieging enemy. This Sallyport, which dates from the late eighteenth century, faces out onto the harbour, and could have been used against an enemy attempting to land on the beach. The pub itself was probably built around the same time, so it may well have been named to celebrate this construction.

The Sally Port Hotel was the location where the diver Buster Crabb spent his last night before his disappearance. His real Christian name was Lionel, but he gained his nickname from the American Olympic swimmer and actor Buster Crabbe, who played Flash Gordon in the 1930s film series. Lionel served with distinction as a Royal Navy diver in the Mediterranean during the Second World War. He continued in this profession when hostilities ended and in 1956 he was recruited by MI6, the intelligence agency dealing with foreign matters. In April of that year he dived to investigate a Soviet cruiser called the *Ordzhonikidze* that was visiting Portsmouth. He was not seen again, at least not by his British contacts, and a body in a frogman's suit that washed up in Chichester harbour fourteen months later was eventually identified as his. Exactly what happened is still not known, but his mysterious disappearance at the height of the Cold War has attracted much interest and many theories ever since. These generally claim that he was captured by the Russians and perhaps killed deliberately, but it is also possible that he simply died in an accident.

Our First Converted Pub

Heading further towards the coastal defences and close to the Square Tower, we come across the first of many Portsmouth pubs that have been converted to other uses, although fortunately this one is still in business as a drinking establishment. This is now known as The Wellington Kitchen Lounge Bar, but was previously a pub called The Wellington. It began in the early 1800s as The Wellington Tavern, which was a very topical name then – it honours Arthur Wellesley, the Duke of Wellington, who fought against the French forces that had invaded Spain and Portugal during the Peninsular War of 1807–14, and then won his great victory against Napoleon at Waterloo in 1815. He also had two spells as prime minister during the 1820s and 1830s.

Old Portsmouth Pubs Away From the High Street

There are three more establishments to look at within the circuit of Old Portsmouth's defences, two of which have changed somewhat from the traditional pubs that they once were.

The first is The Pembroke in Pembroke Road, which heads away from the High Street by the cathedral. The pub is also on the corner of Penny Street and overlooks the open area where the Royal Garrison Church sits.

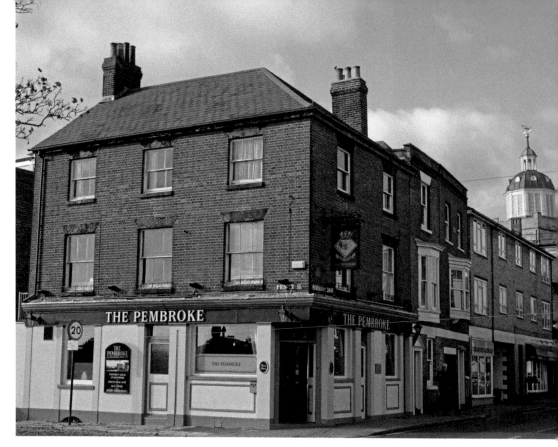

The Pembroke with the tower of the cathedral in the background.

As with a number of Portsmouth pubs, there is more than one theory about the origin of its name. Even when an establishment only dates back to the nineteenth century, the original reason for the choice has often been forgotten. One idea here is that the place is named after one of the earls of Pembroke, a title first created in the twelfth century. Another says that, like a number of the city's pubs, it is named after a ship. There has been a series of Royal Navy ships called HMS *Pembroke* – the first of these was launched in 1655, and the most recent is still in service. The one that was launched in 1812 and continued in service in one form or another until 1905 would fit with the date of the pub itself. Then again, maybe it was just named after its location, since it is in Pembroke Road!

And just to complicate matters, when the pub was first built in the nineteenth century, its name was the Blue Posts. Like similarly-named pubs around the country, this probably came from a pair of posts flanking the entrance. Maybe one day the landlord fancied a change of colour scheme and realised he needed to rename his pub as a result!

The Pembroke now has a single downstairs bar, but up until around the 1980s there were three different rooms at this level. Around fifty years ago when women in the Royal Navy were not allowed to frequent pubs, one of these rooms allegedly formed a good place for them to hide away and enjoy a drink.

The ABar Bistro, another converted pub that still sells beer, is back on the other side of the High Street beyond the cathedral in White Hart Road. Historically there was a pub here called the Shipwright's Arms that was later known as the Forfarshire Tavern, and which was destroyed by Second World War bombing. The rebuilt pub became known as the American and transformed through the names American Bar and A Bar into its present form.

After the Second World War the landlord was a former German prisoner of war. Apparently he had no problems with naval personnel who frequented the establishment, who undoubtedly recognised him as a fellow professional.

The final one of these three is the Mary Rose & Dragon in St George's Road opposite the Landport Gate, so just within Old Portsmouth. The Landport Gate dates from 1760 and was the main entrance into Old Portsmouth – it is the only part of the defences that has survived on this side of the historic town. The Mary Rose & Dragon is an unusual name that warrants explanation. It was built in 1900 by A. E. Cogswell and was originally named the Gloucester Hotel. Then in 1983 the *Mary Rose*, the flagship of Henry VIII that had sunk in the Solent, was raised from the seabed and brought back to Portsmouth. As part of the celebrations, the establishment was renamed the Mary Rose.

Then in 2007 it became the Dragon Bar & Restaurant – more of a place for a meal accompanied by a drink, with an emphasis on Oriental food. Dragons are a good luck symbol in Chinese culture, hence the new name. Then in 2010, the 'pub' element regained an equal footing, and the two names were amalgamated in what is now called a 'Public Bar and Chinese Restaurant'.

Spice Island

Spice Island, or Point as it is also known, is effectively the second oldest commercial and residential part of Portsmouth. Its history is tied up with pubs, so in theory it deserves a chapter of its own. It doesn't get one because there are only three surviving pubs here!

The origin of the name 'Point' is pretty obvious when you look at a map of the area, but Spice Island is less so. Perhaps it came from the goods traded here, although it has also been suggested that the smell of the place in the days before modern drainage may have had something to do with it.

Spice Island long had a reputation for lawlessness and what people of the time called 'immoral behaviour'. It was outside the sixteenth-century fortifications and so was more difficult to control. The presence of many pubs so close to the docks did not help matters. Perhaps only token efforts at cleaning up Spice Island's act were made – some citizens may have felt that such behaviour was bound to happen in a port and were pleased it was not occurring near their own homes within the walls.

In 1716, for instance, there were forty-one public houses here. In the nineteenth and early twentieth century it had not decreased much from this figure. Almost every building must have been a pub, or at least sold beer along with other products.

Of all these establishments, it cannot be a coincidence that two of the three that survive are at the end of Spice Island. Here, at the tip of Point, drinkers have always been able to enjoy views of Portsmouth Harbour and across to the dockyards, and

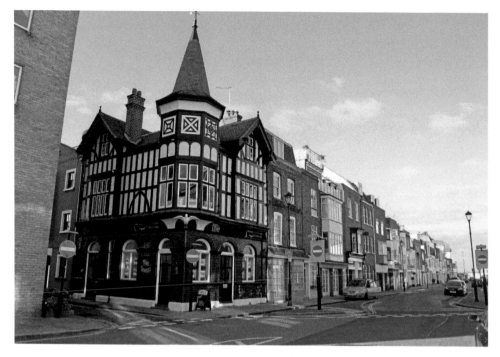

'When I was your age, son, this was all pubs.' In this view of Broad Street, the corner building with the 'witch's hat' on top was once The Seagull pub – a mosaic with this name can be seen on the left-hand wall at ground-floor level. This building is now occupied by an estate agency.

in recent years they have had the Spinnaker Tower as well. These two are our first examples of a feature of a number of Portsmouth pubs – a waterside location. And it goes without saying that the area long ago lost its bad reputation.

The Still & West
The pub is some 300 years old and began life as the Still Tavern, bearing the name of the apparatus in which spirits are distilled. At one time the landlord's daughter married a chap from another Spice Island establishment that has long since disappeared, the East & West Country House, and her father celebrated by incorporating part of that pub's name into his own.

The Spice Island Inn
An important point to make about this establishment, which is the building nearest the 'tip' of Point, is that it has only been a single pub since 1991. The section facing Broad Street had been called the Lone Yachtsman, and the other part, generally facing Bath Square, was the Coal Exchange.

The Lone Yachtsman had been the Union Tavern since the early nineteenth century, the name perhaps coming from one of a series of Royal Navy ships called HMS *Union*, although there are other possibilities, of course. Then on 4 July 1968 Alec Rose

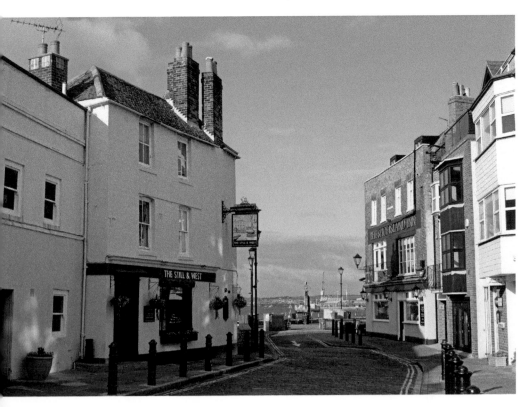

Looking along Bath Square on Spice Island, with The Still & West on the left and the Spice Island Inn at the end on the right.

(subsequently Sir Alec Rose) landed at Southsea after completing a single-handed circumnavigation of the globe, and the pub was renamed in his honour. His vessel was the *Lively Lady*, and this name was given to a bar within the pub. The name 'Sir Alec Rose' has since been taken up by one of the new pubs out at Port Solent.

The Coal Exchange had also changed its name a couple of times. It was first the North Country Tavern, then spent time as the Jolly Sailor before becoming the Coal Exchange around 1859.

The whole thing illustrates how pub names have often changed over the years. (And between them this former pair of pubs have perhaps gone through more changes of name than any other pub in Portsmouth!) The North Country Tavern suggests a link to northern England at some time or other – maybe a landlord was a northerner, or perhaps it was a reference to trade in that area. The name of The Jolly Sailor was clearly intended to attract customers of that profession, so today we wonder why then change it to the 'Coal Exchange', which from a modern viewpoint is unglamorous and might make us think the place is dirty. Presumably the answer is that trade in coal, one of the commodities that was important to Portsmouth, made money and so wasn't stigmatised then.

Though just across the road there is the viewing and seating area at the tip of Point, the views from inside the pub are almost as good thanks to the large and clear windows.

Above: The view of the Spinnaker Tower, Gunwharf Quays and the Historic Dockyard from outside the Spice Island Inn.

Below: Former tram lines by the Spice Island Inn.

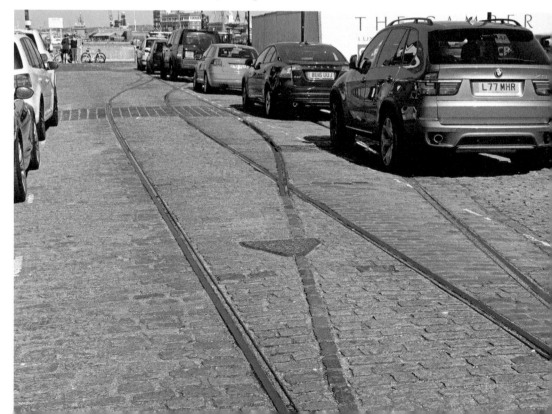

In the parts of Broad Street and Bath Square by the Spice Island Inn you can see the patchy survival of tram lines in the road surface. These belonged to Portsmouth's former tram network – as you might expect one of the lines terminated here. After the trams stopped running, the lines were left in place as a feature of this historic area.

The Bridge Tavern

The Camber is the body of water that lies on the east side of Spice Island. It was the original harbour when the town of Portsmouth was founded in 1180. Take the footpath that leads around the south side of the Camber, heading from the landward end of Spice Island towards the Isle of Wight ferry terminal and Gunwharf Quays, and you look across to see a pub that looks rather inviting, though now dwarfed by the Camber Development, where the America's Cup team are currently working. However, it is not immediately obvious how to get to this establishment – The Bridge Tavern. To do so, you have to retrace your steps to Spice Island and then turn off right from Broad Street. You head through a dock area that is East Street, and find the pub on the end. You will very probably find this effort to have been worthwhile.

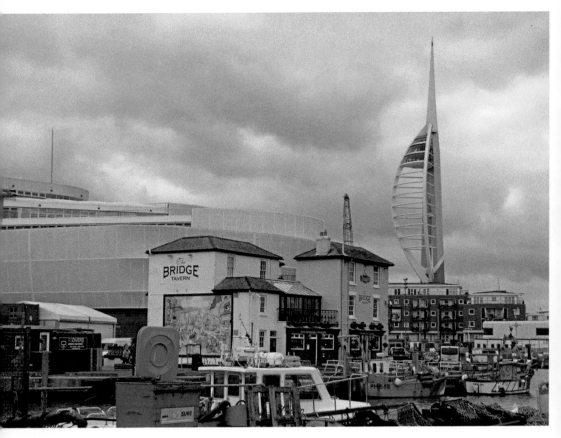

The Bridge Tavern, seen from the south side of the Camber. Part of the Camber Development is behind it to the left.

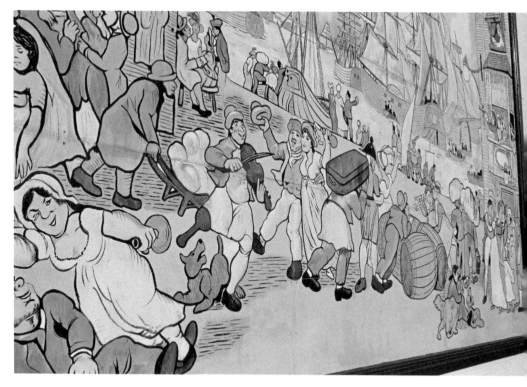

Above: A detail of the mural on The Bridge Tavern, showing various unseemly goings-on.

Below: Part of the upstairs dining area of The Bridge Tavern.

East Street once had many pubs. Whereas elsewhere on Spice Island the pub buildings have changed to other uses, The Bridge Tavern is the only such structure to survive on East Street.

A striking feature of the building, when you get close, is the mural that occupies a whole wall on the outside. It is a version of a famous caricature of the activities of Spice Island by the artist Thomas Rowlandson (1756–1827), which in its day did much to cement that area's rather questionable reputation.

The pub was built in 1806, on a site that had once been a brewery, though its present name is of more recent origin, coming from an iron lifting bridge that was constructed across the Camber in 1842. This was replaced by a swing bridge in 1906, which in turn was removed in 1923. The iron bridge is depicted on the pub's sign.

Like many other Portsmouth pubs, inside there is much nautical memorabilia, including lots of framed pictures. Appropriately considering the pub's next door neighbour, some of this relates to early America's Cup competitions, such as those of 1899 and 1901 when the American vessel *Columbia* beat *Shamrock* and then *Shamrock II*, both from the Royal Ulster Yacht Club and sponsored by Sir Thomas Lipton of tea fame.

And in a fine pub tradition, The Bridge Tavern has its resident ghost. This is said to be Max, the former owner of the place, who is said to have died on the very day that it became a chain pub.

Portsea and Landport

In this chapter we move away from Old Portsmouth through its earliest suburb, Portsea, which was first developed in the eighteenth century, and inland to Landport, which is now the city's main shopping and commercial centre.

Gunwharf Quays

To the north of the Camber there is what has become Portsmouth's iconic shopping area, where there is a number of new bars. The development is on the site of the navy's former munitions storage area (hence 'Gunwharf'), which became HMS *Vernon* in its latter years. Many of the drinking establishments are new-builds, but an exception is The Old Customs House. The building in which it is located dates from 1790 and as the name suggests, before the Gunwharf development took place it was the customs building of HMS *Vernon*, the navy's torpedo establishment.

The Hard

Moving north past Portsmouth Harbour railway station we come to The Hard, which is by the entrance of the Historic Dockyard. Nowadays the name is applied to the road here, but the original Hard was a landing area for ships. It was literally a hard surface up which boats could be hauled for repairs. This was constructed around 1710–20 from ballast, the heavy material that a sailing vessel returning empty to its port would need to hold itself steady in the water, and which would be dumped once it reached its home port. The area was sometimes called The Common Hard but it could be used by all vessels, unlike the area to the north that was restricted to naval ships only.

Like Spice Island, The Hard formerly had a bad reputation stemming from drunken behaviour and the presence of a variety of people who were considered unsavoury, from prostitutes to con men. For sailors landing after long sea voyages, which often involved bad food and harsh conditions, this would have been the first area where they were able to relax and enjoy themselves, and indeed simply to move around freely after the confines of a ship. Naval men coming out of the dockyard would be largely free of military discipline once they came through the gates, and there would also be civilian sailors whose vessels had landed at The Hard. Most would have been paid at the end

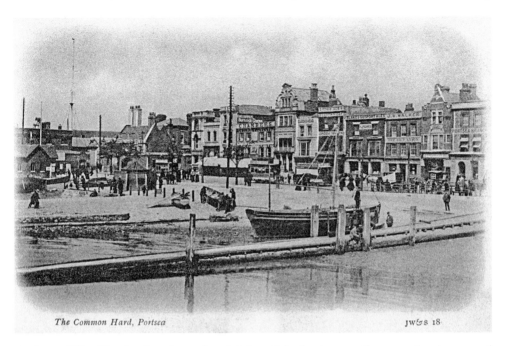

The Common Hard, Portsea JW&S 18

A view of The Hard, taken from the vicinity of the harbour railway station in around 1900. Part of the naval dockyard is on the left. Among the row of pubs and hotels facing The Hard, the tall, narrow, four-storey building is the version of The Ship Anson that was demolished in 1922.

of their voyages, which attracted lots of people keen to take some of their money, whether legally or otherwise.

It is no surprise that pub names celebrating individual ships and other maritime themes have always predominated here.

Ideally Situated

The Ship & Castle is on the left-hand end of the row as you face it, on the corner with Queen Street. It is immediately opposite the dockyard entrance, which must have been the very best location for a pub in Portsmouth back in the day. Considering how many visitors to the Historic Dockyard must come out feeling peckish and thirsty after spending time seeing all the attractions there, it is still not in a bad spot!

Seen from The Hard it does not seem particularly big, but go round the corner and you see that it must be the longest pub in the city. Although there has been a pub called the Ship & Castle on this spot for centuries, the present building only dates from 1901 and was designed by A. E. Cogswell. The pub fell into disuse in the 1970s and potentially could have been demolished when a road widening scheme was proposed, but it reopened after a major overhaul of the building in the 1980s.

The origin of the pub's name deserves a bit of speculation. The pub's sign is painted up on the wall of the curved corner of the building that faces the dockyard entrance, and it interprets the name literally, with a ship at sea in the foreground and

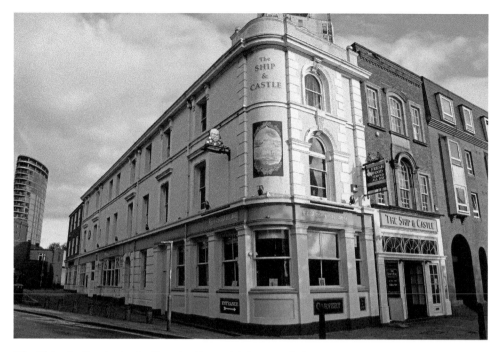

The Ship & Castle, including the 'long side' around the corner.

a castle on land in the background. The castle is said to be Dover Castle. While there might be some now-forgotten connection between this pub and Dover Castle, likely explanations are that the castle from which the pub got its name was either Portchester Castle, at the head of Portsmouth Harbour, or even Portsmouth's own fortifications. This is perhaps strengthened by the fact that there were formerly two other pubs of this name in Portsmouth. Another possibility comes from parts of a ship. The forecastle (or fo'c'sle as it was pronounced and sometimes written) was an elevated part of the deck in the forward part of the ship, and medieval ships often had another raised area near the stern called the aftcastle. The defences around these areas on military vessels did indeed make them look like miniature castles. Perhaps at one time the inn sign showed this type of ship and the name stuck.

Two Into One Will Go

A few buildings along there is The Ship Anson. There have been eight Royal Navy vessels called HMS *Anson*. The pub is most likely to be named after the first of these, which was launched in 1781 and sank on the Cornish coast in 1807. In turn, the ships bear the name of George Anson (1697–1762). Between 1740 and 1744 during a war with Spain, he led eight ships on a voyage around the world to attack Spanish lands and wealth in the Pacific. A great success was the capture of a Spanish galleon with a cargo of over a million pieces of eight, but he lost many men and most of his ships during the voyage. The capture made him rich for life, and he later became a Member of Parliament, the First Lord of the Admiralty and a baron.

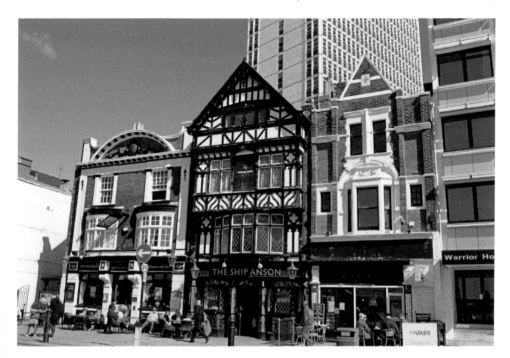

The Ship Anson today. The black-and-white Tudor-style building is Cogswell's 1922 rebuild, and the former King & Queen is to the left.

I think this is the last survivor of a type of pub name of which Portsmouth once had several, these being in the form 'The Ship X'. The name of another, one of two former Portsmouth pubs called 'The Ship Leopard,' survives as the name of a boutique a few doors along to the right.

The pubs now occupies two very distinct buildings. The taller mock-Tudor one on the right as you face them across The Hard was a replacement of the original pub built in 1922 to a design by A. E. Cogswell. The one on the left was originally a separate pub called the King & Queen, which was amalgamated into The Ship Anson in 1967. The King & Queen was apparently named after the chess pieces rather than a particular pair of monarchs, and its frontage was also altered at some point during the twentieth century.

Several doors along there is The Lady Hamilton. It was once a pub called The Nag's Head, a common name that must have originated as a nickname from pictures of a horse's head on pub signs. The pub closed nearly a century ago and the building was converted to other retail uses, then reopened as a pub in the 1990s. The present name follows the nautical theme – Emma, Lady Hamilton was the mistress of Admiral Nelson. The pub is closed at the moment.

An Observant Waiter

Two doors further along we find the Keppel's Head Hotel, now a hotel in the modern sense but formerly also a drinking establishment. It was built in 1779 after a fire destroyed several properties in the immediate area, and was given a very topical name.

In January and February of that year Admiral Augustus Keppel was court-martialled at Portsmouth. He was acquitted of a charge of 'dereliction of duty' over his actions in command of the British Fleet during the First Battle of Ushant in July of the previous year. The battle was fought off the French coast against that country's fleet and from the British point of view the result was at best indecisive, and possibly a defeat. Not only was he acquitted, but Keppel was exonerated as a 'judicious, brave and experienced officer'. Keppel was a popular man by now, and there were great celebrations in Portsmouth following the verdict. Apparently several inns used his image on their sign and, in the case of this one, it has survived to this day.

The Keppel's Head remained popular with naval men to the extent that when there was another fire here in 1803, officers and midshipmen paid for its reconstruction. They also called it affectionately 'The Nut'.

There is a nice story about a waiter called William who worked here in the later nineteenth century. At the time The Keppel's Head was particularly popular with young naval officers, many of whom were studying for service exams. William was renowned for predicting the grades they would receive with great accuracy. Undoubtedly some believed he had powers to tell the future, though the wise cottoned on that he predicted their level of success in inverse proportion to the amount of time they spent in this establishment.

More Ship Names

Then further to the right there is The Victory in the angle of the junction with College Street. It probably wins any competition for the best ship name for a Portsmouth pub! The present building dates only from 1976, and at the time of writing it was closed and due for demolition, though a new pub is planned, apparently for the new development that is intended here.

Going back to the Queen Street end and around the corner, the far end of The Ship & Castle is at the junction with Wickham Street, and just down here there is The Invincible, whose name perhaps runs The Victory a close second. It was renamed in 1983 from HMS *Invincible*, which had seen action in the Falklands the previous year.

A Source of Both Beer and Water

A short distance further along Queen Street we find The George Hotel, a very well turned-out establishment, which was built sometime around 1760. We are now moving away from nautical themes for names, but the pub was given a good patriotic one, especially as technically its full name is The King George. Presumably this came from the reigning monarch when it was built, either George II (1727–60) or his grandson George III (1760–1820).

There were two buildings here in the eighteenth century: the pub and a shop. In the following century the shop was amalgamated into the pub, and the courtyard that originally separated them was covered over. During restoration work to the pub in the late twentieth century a well was rediscovered – originally it had been in the courtyard and had served both of the properties. The well is now on display in the pub's main bar.

Above: The George Hotel in Queen Street. The tiling below the left-hand ground window has the inscription 'Jewell & Son's Ale' and is a unique survival of this former Portsmouth brewery.

Below: The dining area of The George Hotel.

The rediscovered well inside The George Hotel.

Guildhall Walk

From here we have to cross something of a pub desert, mainly the result of destruction by wartime bombing, before finding more watering holes closer to the present city centre, just south of Guildhall Square.

The Brewhouse & Kitchen is on the corner of Guildhall Walk and White Swan Road – the latter preserving the former name of this pub. The White Swan dates from the early 1900s and was designed by A. H. Bone in something of a Tudor style. The pub was popular with actors starring at the nearby Theatre Royal, and as is often the way with pub names, it gained the nickname 'The Mucky Duck'. A few years ago it became part of the Brewhouse & Kitchen chain, which, as the name suggests, brews its own beer on the premises.

Further up on the same side, on the corner of King Henry I Street and looking across Guildhall Square, there is the Isambard Kingdom Brunel, which was Portsmouth's first Wetherspoons pub. It opened in 1996 in former gas company premises. The pub is of course named after a 'local boy', for the great engineer was born on 9 April 1806 in Britain Street in Portsea. His father was an escapee from the French Revolution, Marc Isambard Brunel, who set up a successful business in Portsmouth making pulley blocks for the Royal Navy.

Round the corner in King Henry I Street there is The Fleet, which was once The Fleet & Firkin. In this earlier role it was part of the Firkin Brewery chain of pubs, which specialised in brewing their own beer on the premises (although this one never

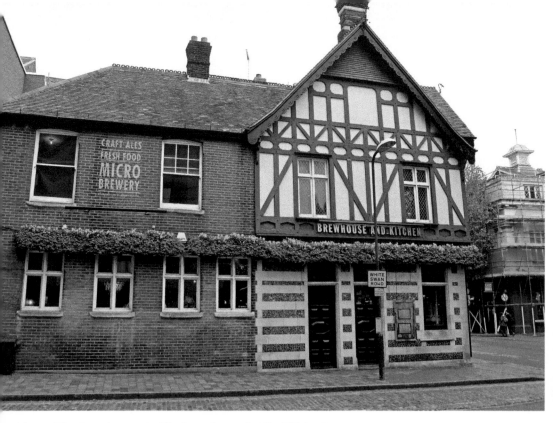

Above: The Brewhouse & Kitchen, formerly The White Swan.

Below: The Fleet.

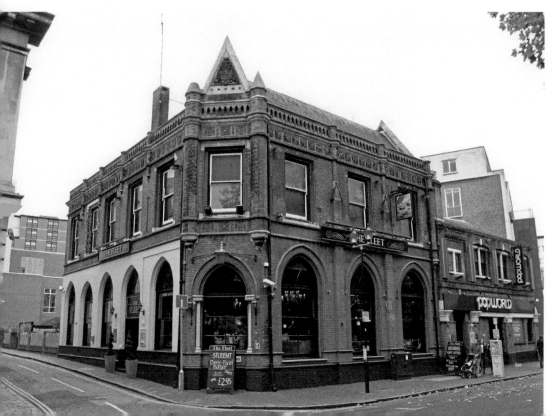

did, apparently). The Firkin pubs were very much the in-thing in the 1980s and early 1990s. They had started up in 1979 in London and for several years they were limited mainly to the capital – I remember when visiting a friend in London in the late 1980s that he was keen to show off one near his home. They were 'cool' not just for brewing their beer, there were also the potentially risqué pronunciation of 'Firkin' (which was really just an old measure of the volume of beer) and the fact that each pub that opened had an animal name or a local connection – they were all the 'X and Firkin'. So when one opened in Portsmouth, the choice of 'The Fleet & Firkin' was obvious, especially as additional names beginning with 'F' were favoured. When the chain was taken over and the Firkin pubs lost their specific identity, this pub's name was shortened simply to 'The Fleet'.

Two Pairs of Old Pubs

Then up past the main railway station we head into modern Portsmouth's central shopping area in Commercial Road. A short distance up here Edinburgh Road runs off to the left, and down it there is a pair of traditional pubs, on opposite corners of a side street. As you face them, The Royal Standard is on the left, almost dwarfed by the surrounding buildings, and The Park Tavern is on the right in a larger three-storey building.

The Royal Standard was built in 1887 to a design by A. H. Bone, and is known to locals as Ruby's, after a landlady called Ruby Hardwick who ran the establishment

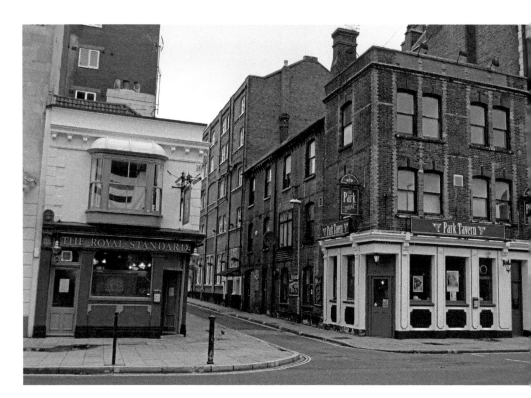

The Royal Standard and The Park Tavern in Edinburgh Road.

for forty years. The Park Tavern was originally called the Battle & Breeze after an old naval term, but then changed its name to the present one in 1878 to commemorate the opening of Victoria Park that year. The park is a short distance from the pubs across a road junction.

At the far end of the Commercial Road shopping precinct, and just around the corner, we find another pair of traditional pubs, separated by only a few more yards than the previous pair, and each roughly a hundred years old. These are The Painters Arms in Lake Road and The Mars just down Spicer Road that runs off it.

There are two possible origins for the name of The Painters Arms. The first is the obvious one that it comes from the trade – for many pubs have trade names such as the Carpenters Arms. But it may be that it was named after an eighteenth-century criminal, or perhaps 'terrorist' would be a more accurate description.

This was an individual whose exact name is uncertain – it may have been James Aitken or John Aitkin – who was commonly known as John the Painter or Jack the Painter. He was born in Scotland in 1752 and probably wasn't very good at the trade that gave him his nickname, for he turned to crime and ended up going to what were still the American colonies, effectively to avoid punishment. He became involved in the American Revolution and then returned to England. Mainly on his own initiative, he decided that arson in Royal Navy dockyards in Britain could help the Revolutionary cause. He started fires at Bristol and Portsmouth dockyards, without

Distinctive glazed, brown brickwork on The Mars.

causing a great deal of damage, but was then caught and brought to Portsmouth to face trial. He was found guilty and sentenced to hang.

His hanging on 10 March 1777 was no ordinary execution; there was clearly a lot of public interest and, as with Felton who assassinated the Duke of Buckingham, the authorities wanted to make an example of him. A mast was taken from a ship, HMS *Arethusa*, and set up at the dockyard entrance to form the highest gallows ever erected in England. Twenty-thousand people are said to have witnessed the event. And again, as with Felton, the Painter's remains were put on public display, this time on a nearby beach, although there is no record of any public sympathy being expressed over this.

The Mars is not named after the planet (and I might add facetiously not after a chocolate bar either). It was originally called the Olive Branch, after the traditional peace offering, which seems ironic considering what the name was changed to. In fact, around the beginning of the twentieth century, when Europe was heading to the First World War and people in general were feeling militaristic as a result, several local pubs changed their names in accordance with this attitude. This pub was affected by this trend, being renamed after a ship which in turn was named after the Roman god of war. The ship in question was built in the 1840s at Chatham and saw action in the Crimean War before seeing out her days as a training ship. The pub was then rebuilt in 1923 to a design of A. E. Cogswell.

Southsea

Although an historic area, Southsea is by no means as ancient as Portsmouth itself. The first record of the name is when it is applied to Southsea Castle in 1544, and for the next two and a half centuries the only buildings in the area were a few scattered farms. Then around 1800 development got going, and as housing rapidly spread across the area, pubs were also built for the thirsty inhabitants. Southsea was also a holiday resort, and indeed was often seen as a separate place from Portsmouth, and this leisure aspect is reflected in some of its hostelries.

Heading Into Southsea

We start a tour of some of Southsea's many pubs by retracing our steps through the city centre, crossing the big dual carriageway that is Winston Churchill Avenue, and heading down Middle Street, just east of the university. Along this street and its continuations as Eldon Street and Norfolk Street, there are three pubs.

The first pub we encounter is The Raven, which was built in 1966 on the site of a predecessor called the Middleton. Its sign shows a very well-dressed raven with a walking cane and raising his hat in greeting.

The Eldon Arms is a little way further on in Eldon Street. Street and pub are probably named after one of the nineteenth-century earls of Eldon, the first of whom was Lord Chancellor (Eldon is in County Durham) – the sign certainly shows the family crest. From outside the building looks a little like The Ship Anson, with a large building on the right and a smaller cottage next door into which the pub has expanded. The frontage of the larger one displays the name of the Eldridge Pope brewery which once owned the establishment – that brewery operated in Dorchester in Dorset from the 1870s until the 1990s.

Like The Eldon Arms, the third of this group has a very ornate frontage. This is the King Street Tavern, sited at the junction of Eldon Street and Norfolk Street with King Street. This pub opened in 1852, and the frontage was added in the late 1880s from a design by Cogswell. It has only borne the name of the street since 2006, having been formerly called The Diamond, probably after a Royal Navy ship of that name.

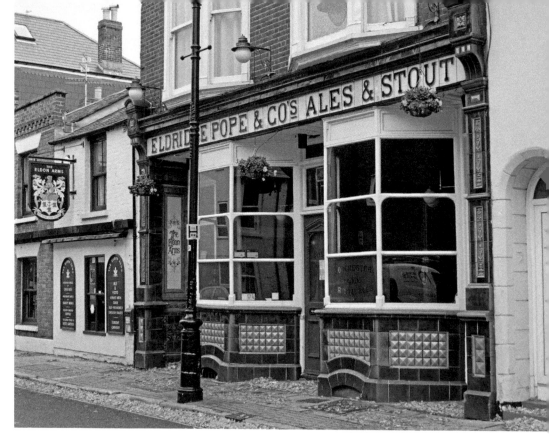

Above: The Eldon Arms proudly displaying the Eldridge Pope name.

Below: The highly decorative frontage of the King Street Tavern.

Towards Southsea Common

Norfolk Street ends at Kings Road, and a slight dogleg from here takes us down Great Southsea Street. The Hole In The Wall is on the right as we head down here. At first sight it looks like a traditional-style pub that has been here since the area was first developed, but in fact it only opened in 1998, though it has gained an excellent reputation in its relatively short existence. Even if you didn't know that it was quite a new pub, there is a clue in its location. It is within a terrace, albeit by a gap with a driveway, whereas most pubs that were planned as parts of Portsmouth's expanding suburbs were built on street corners.

Great Southsea Street runs diagonally into Castle Road, and just back round the corner in this road there is The Barley Mow, designed by our friend Mr Cogswell in the mid-1920s. The pub once displayed a painting that is now in Portsmouth Museum. This work, by E. Dugan, depicts the so-called 'Battle of Southsea', which took place on 7 August 1874. It was set off by the owners of Clarence Pier preventing access to those they thought 'undesirable', then blocking off an adjacent section of the Esplanade to reinforce this. Some of those who were excluded burnt the barriers and rioted over several evenings until, on the 7th, the mayor brought in police to disperse the rioters, with the army waiting in reserve. Several rioters were injured, but the pier owners decided to permanently remove the barriers.

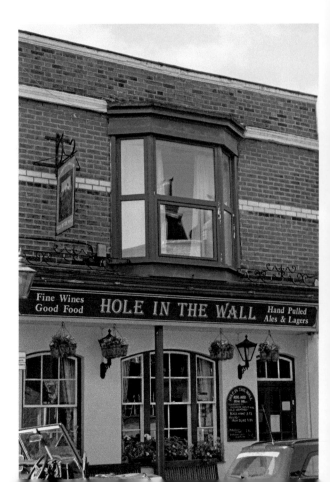

The Hole In The Wall.

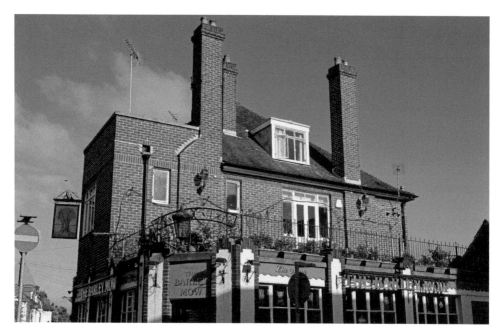

Some sizeable chimneys on The Barley Mow.

The painting is by the stairwell at the end of the ground floor in the museum, and depicts a variety of persons knocking the living daylights out of each other. It is circular, which suited its original location on the ceiling of The Barley Mow, though you hope it didn't give the customers any ideas.

A King's Mistress

Castle Road continues south to a corner of Southsea Common. From this point Southsea Terrace runs along the north side of the Common, and a few doors along here we find our next pub, but first an historic connection deserves a mention. The building in the angle between the two roads was the birthplace of the comedian Peter Sellers, best known as one of the Goons on radio in the 1950s and for film roles such as playing Inspector Clouseau. He was born here in 1925 and made his stage debut when carried on stage at the Kings Theatre, Southsea, when only a fortnight old. The building is now a Chinese restaurant with a blue plaque commemorating Sellers' birth.

Now to get back to the pub: The White Horse is an early eighteenth-century building that is set back from the road, with lots of seating in front from which to look out across the Common. It has only had its present name since around 1950; before then it was The White Lodge, which probably tells us the original colour of the building in contrast to the present orange. A quarter of a century ago it went through a phase of being called Langtry's after Lillie Langtry, known as the Jersey Lily and the mistress of the future Edward VII. Langtry stayed here during visits to Portsmouth when The White Lodge was not yet a pub, allegedly having what polite society called 'liaisons' with the then Prince of Wales while here.

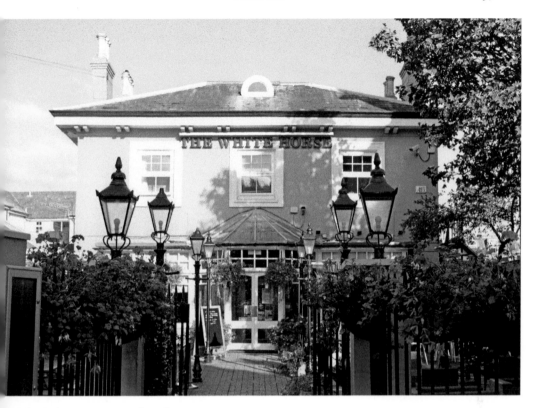

The White Horse catches the sun.

Next-door Neighbours

Going south-east around Southsea Common, Auckland Road West is a back road that runs from the Common round to Palmerston Road, and is easily missed. It is better not to do so, though, as you will not see two fine little pubs that sit side-by-side. These are The Apsley House and The Auckland, two similarly-sized buildings, as seen from Auckland Road West at least, that are attractively decorated in differing styles.

The Apsley House has only been a pub since 1944. Previously it had been a private house and at one time a school. The date of it gaining its licence seems significant – so many existing pubs in the central Portsmouth area had been destroyed or badly damaged by bombing earlier in the Second World War that there must have been a shortage. Also, this was the year before the war ended when there was optimism that victory was in sight, and people were aware that the worst days of bombing raids were over.

The Apsley House is named after the home of the Duke of Wellington, which is at Hyde Park Corner in London and is still a tourist attraction today. The duke bought the house in 1817, two years after his great victory over Napoleon at the Battle of Waterloo, and lived there until his death in 1852. Wellington had the house redesigned and it became a monument to Waterloo, so it also gained the nickname 'No. 1 London'. This pub used to have a painting of its London namesake on its frontage, with the inscription 'No. 1 Portsmouth' beneath – a nice touch!

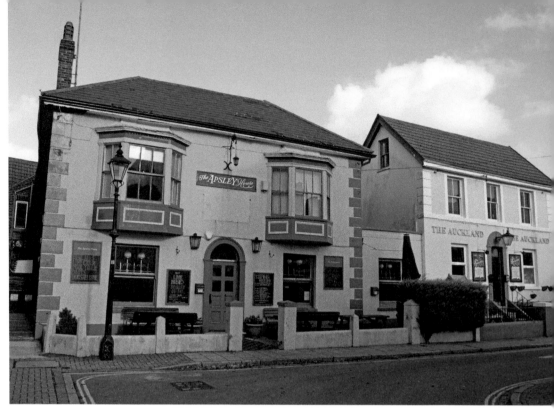

Above: Good neighbours! The Apsley House and The Auckland by a corner of Auckland Road West, a short distance from Southsea Common.

Below: The Apsley House retains its traditional interior, including the bar.

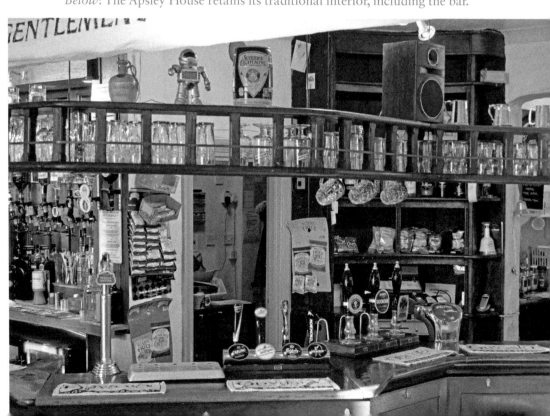

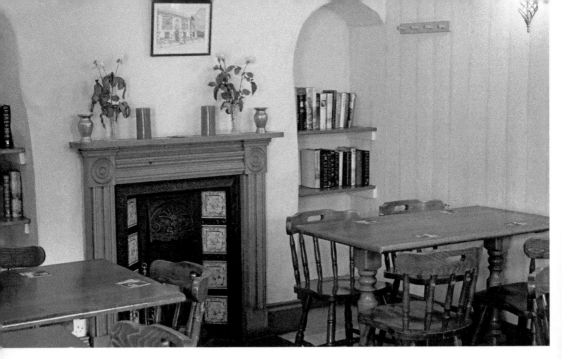

A raised area within The Apsley House that has been decorated in the style of a living room.

The Auckland was built in the 1880s. Today we might assume the name 'Auckland' refers directly to New Zealand, but the pub is actually named after a politician called George Eden (1784–1849), who was the first Earl of Auckland. He held the title of First Lord of the Admiralty (hence his Portsmouth connection, presumably) and was also Governor-General of India. It was while he held the latter post in 1840 that the new capital of New Zealand was named 'Auckland' in his honour. The 'Auckland' from which Eden got his title was West Auckland in County Durham, near the better known Bishop Auckland.

Having compared the sizes of the two pubs, I have to add that the Auckland is on the corner of another street called Netley Road, and that it has a second frontage along here, including an advertisement for Long's Ales.

An Excellent Choice of Name

A little further south, Osborne Road leaves Southsea Common by the Queens Hotel and runs east towards Southsea's central shopping precinct. Partway along there is a new establishment with rather an interesting name. This is The Wave Maiden, which opened in late 2014.

Wave Maidens come from Scandinavian mythology – they were also known as Valkyries. They were the nine daughters of a sea god who were said to follow Vikings to battlefields where they chose those warriors who had died most valiantly and took them to Valhalla, which was the Viking idea of heaven (it involved quite a lot of drinking!). Portsmouth's associations with the military make this a particularly good name for a pub, and of course 'The Wave Maiden' is more appropriate than 'The Valkyrie' in a city with so many nautical connections.

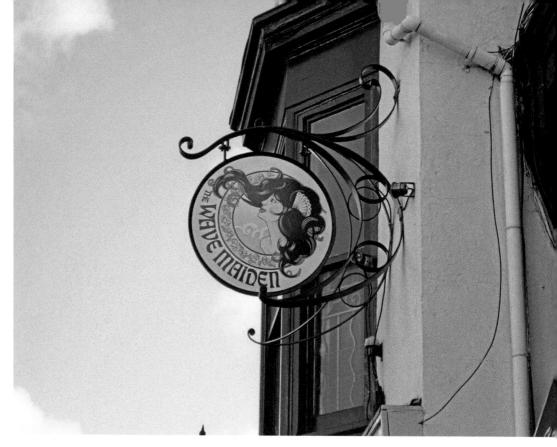

The modern and yet traditional sign of The Wave Maiden.

Palmerston Road

Palmerston Road runs from the pedestrianised main shopping street of Southsea south towards the Common. It is named after the Victorian prime minister whose full name and title were Henry John Temple, 3rd Viscount Palmerston. In 1859 a royal commission warned of the danger of French invasion, recommending fortifying Portsmouth and other important ports. Palmerston acted on this, and the two most obvious series of fortifications built locally are the forts on Portsdown Hill and those in the Solent.

The former are massive redbrick structures built in the 1860s and named as Forts Wellington, Nelson, Southwick, Widley and Purbrook, and then Farlington Redoubt. The first two were named after the heroes of the Napoleonic War, and the others after nearby villages. They are often called Palmerston's Follies after the prime minister because they were never used and had guns facing inland. To defend Palmerston, the lack of use was due to improved relations with France by the time they were finished and perhaps their deterrent value, and the guns faced away from Portsmouth and the sea because they were intended to defend against a force that landed elsewhere on the coast and approached from the north.

The Solent forts do perhaps deserve some criticism in that work did not start until 1865 and by the time they were finished fifteen years later there was no real threat of an invasion by France.

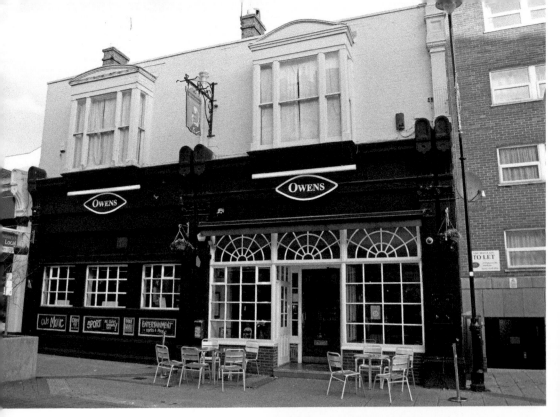

Above: Owens in Palmerston Road.

Right: St Jude's Church at the northern
end of Southsea's main shopping street
is one of many buildings in the area that
were the work of Thomas Ellis Owen.

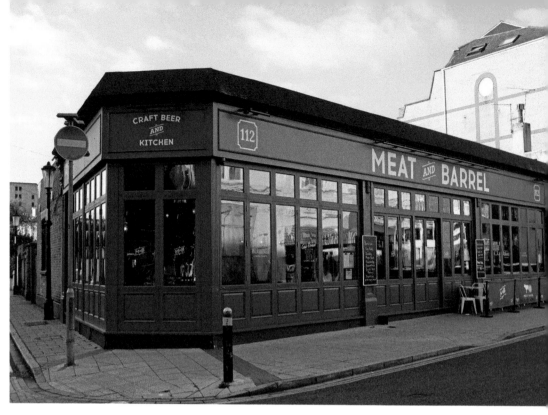

The unusually shaped single-storey building that is the Meat and Barrel.

On the west side of Palmerston Road we encounter our second Wetherspoon's establishment. This one opened in 2010 and it took its name not only from the road but also from a pub's old name by being called The Lord Palmerston.

The pub whose old name it revived is just across the road. This is called simply 'Owens', a name it has had since 1981. It opened as a pub in 1948, having been converted from a shop, and its owners presumably were capitalising on the pub shortage caused by Second World War bombing. When it did so, it took the name 'The Palmerston'. The present name also refers to a person with strong local connections, in this case the architect Thomas Ellis Owen, who planned the layout and designed many individual buildings for the expansion of this part of Southsea around the 1840s. He is often described as an architect, although one authority simply calls him a 'speculator'.

Also deserving of a mention in Palmerston Road is an establishment that is closer to the Common. This is the Meat and Barrel, which opened in 2014 in a former Chinese restaurant. The name sums up admirably what you can expect to purchase inside, and the building has a nice distinctive design and a spacious interior.

Inspired By a Poem

The pub known until recently as the Marmion Tavern, and now simply as 'The Marmion', is in Marmion Road on the east side of Southsea's main shopping area.

'Marmion' in the pub and road names comes at second-hand from a character in a poem. They were built on land that formerly belonged to a Mr J. Webb, whose home

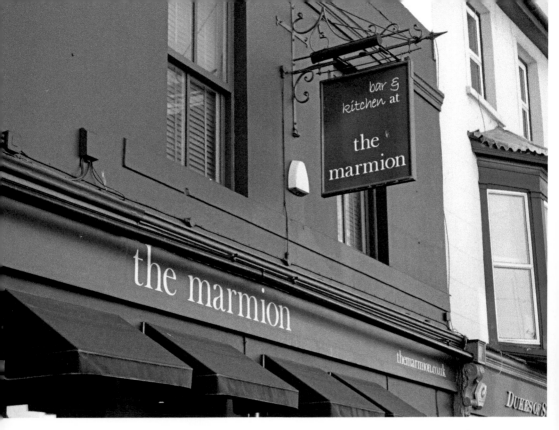

A detail of The Marmion, which has been decked out recently in a very fashionable black.

was also 'Marmion'. He or whoever else originally named the house must have been a fan of Sir Walter Scott, for a poem of his written in 1808 tells the story of a Lord Marmion. Scott is remembered today more for his novels, of which the best known is *Ivanhoe*, which lists Robin Hood among its characters.

However, this building has only had the name 'Marmion' since 1976 – the name originally belonged to a now-closed pub across the road. Before this changeover, it had been The Lord Napier, named after Sir Charles Napier (1786–1860), an admiral in the navy and later a Liberal MP. He must have been popular locally for the reforms he proposed for the navy, such as better rights and pay for sailors and the abolition of flogging and press gangs.

Along Albert Road

Earlier in this chapter we crossed over Kings Road while heading southwards in the direction of the Common. Kings Road itself becomes Elm Grove as it runs east, where there is a variety of pubs, bars and other establishments among the many businesses lining the road.

At its eastern end Elm Grove forms a T-junction with Victoria Road, which itself becomes either Victoria Road South or Victoria Road North, depending on which way you now travel along it. A short distance down Victoria Road South it forms a junction with Albert Road. These roads were named after Queen Victoria and her husband

Prince Albert of Saxe-Coburg by the patriotic developers of the area. On the corner here is a pub which in turn is called the Victoria & Albert, but it has only had this name for a few years. It was once a police station, and it was first converted into a pub in 1996 by the Firkin chain that we encountered at the Fleet & Firkin in Landport. In this case the former occupants provided the pub's original name – it became the Fuzz & Firkin.

The bars and pubs continue along Albert Road, showing what a popular and successful area this is for spending your social life. I will pick out some of these, mainly the more traditional-style pubs.

The main landmark hereabouts is the Kings Theatre, and there are several pubs and bars around it. Prominent among these is The Kings, a sizeable three-storey brick building across the road that fully occupies the smaller corner of a junction. It was opened in 1910 as The Kings Hotel, taking its name from the theatre, on the site of what had been The Clarence Hotel. To either side of it are other establishments called Porters and The Vaults, while on the same side as the theatre there is Little Johnny Russell's, known in the twentieth century as the Lord John Russell.

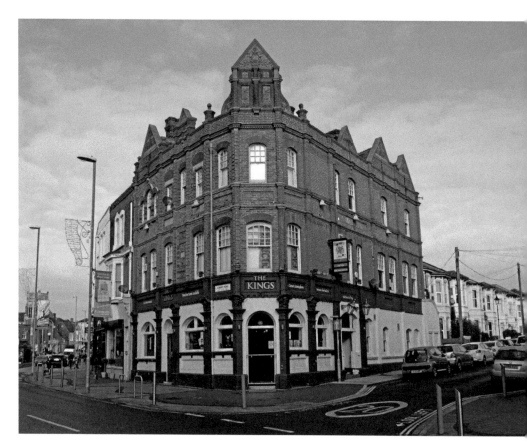

Seen from outside the theatre after which it is named, The Kings fits snugly into a triangular plot of land at a road junction.

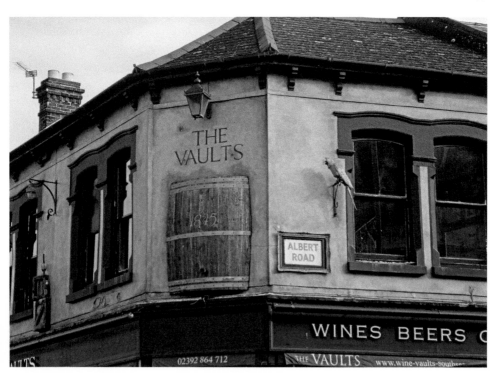

Above: Part of the upper storey of The Vaults.

Below: The signs of The Phoenix depict the bird killing itself in flames. And the pub appears to have a royal visitor!

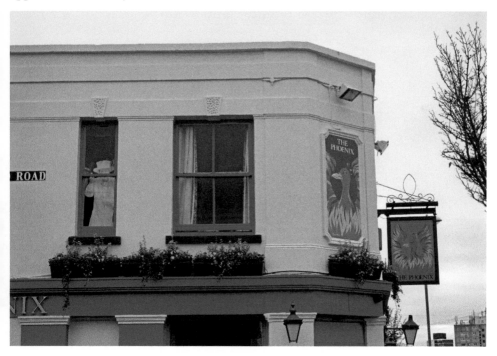

As we continue eastwards, we need to make a short diversion down Duncan Road to its junction with Collingwood Road for a look at The Phoenix. This brightly decorated pub was once called the Brewery Tap as during the nineteenth century it served the products of the Dockmill Brewery, which later became known as the Phoenix Brewery before being taken over by Brickwood's.

The phoenix was a bird in Greek mythology. It would kill itself in a fire, from the ashes of which a new phoenix would be born. Hence its name is often used for buildings that have been rebuilt following a fire. In this case, though, the pub's name clearly comes from that of the former brewery, which may have suffered a fire, although the brewery could also have been renamed after one of a number of the navy's vessels that have been called HMS *Phoenix*.

Back on Albert Road, at the next junction there is the 5th Hants Volunteer Arms, which has sometimes been called simply The Volunteer Arms. It takes its name from the 5th Hampshire Rifle Volunteer Corps that was formed in 1860, and the pub's signs depict a red-coated nineteenth-century soldier refreshing himself appropriately while on the march.

Then on the north side of the road there are two adjacent pubs. The first is The Royal Albert, which was probably named after a ship, HMS *Royal Albert*, which was launched in 1854. Indeed the pub sign used to show a steam ship of the same type as this vessel, although the location in Albert Road may also have influenced the choice of name. The pub's sign now shows what looks like a sheep wearing a crown.

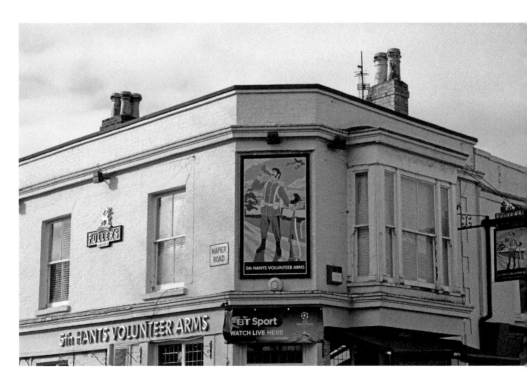

A detail of the 5th Hants Volunteer Arms.

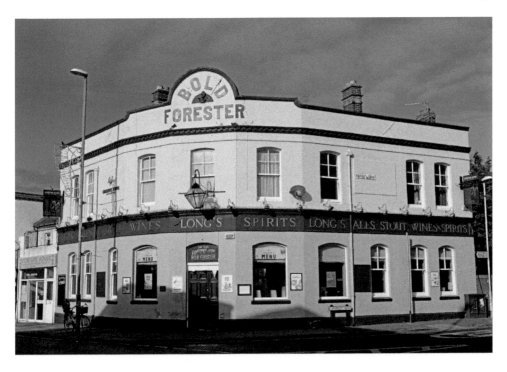

Above: The impressive early nineteenth-century frontage of the Bold Forester.

Below: The distinctive green glazed tiles of The Leopold fit in well with its colour scheme.

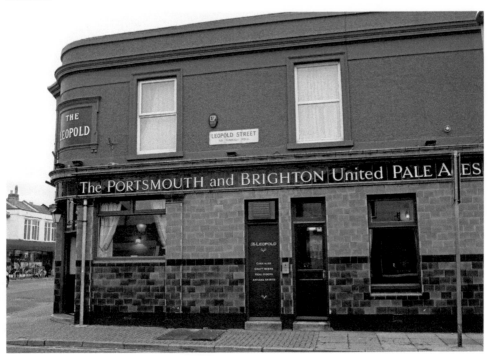

Next door there is the Duke of Devonshire, renamed after one of the aristocrats who held this title after starting life as the Prince of Wales.

The Bold Forester comes a little further along the north side of Albert Road, on the corner with Fawcett Road. It is a large building whose frontage extends along both roads, with a polygonal corner and the pub's name displayed boldly on the parapet. The frontage also bears the name of an old Southsea brewery, Long & Co., as well as that of the present owners, Greene King. The pub's name may reflect associations with the New Forest or other wooded parts of Hampshire, from which came the timber used in naval and civilian shipbuilding. The role of a forester in managing woodlands would have been of considerable economic importance.

The Leopold Tavern is immediately opposite on the south side of the street. It is on the corner with Leopold Street, so this is probably one of those cases of the pub being named after the street. However, it may be that the person in question is Leopold I, Queen Victoria's uncle and the first king of Belgium. He was crowned in 1831 after that country declared itself independent from the Netherlands. The pub sign bears the king's image. The exterior of this pub has a very attractive design. At ground floor level there are green glazed bricks in two different shades, which are set off nicely by the black paintwork at first floor level. In between the former owner, the Portsmouth & Brighton United Brewery, is still commemorated.

And then there is The Festing, named after Colonel Sir Francis Worgan Festing (1833–86) of the Royal Marines. He served in the Crimean War of the 1850s, then in China and Africa and, while posted in Portsmouth, led the rescue of crew members from a schooner that sank off Hayling Island, for which he was awarded the RNLI's Silver Medal for Gallantry. The colonel is buried in Highland Road cemetery at the eastern end of Highland Road.

The pub itself was designed by A. H. Bone and was one of two local pubs that served as hotels for a long-lost railway station. Since there is no obvious evidence for a railway around here, this needs a bit of explanation. For around thirty years, Southsea had its own railway branch line, named the Southsea Railway. This opened in 1885 and was 1.25 miles long. The branch left the main line at Fratton Station and curved slightly eastwards as it headed south to a terminus near what is now a roundabout at the western end of Granada Road. In 1904 two intermediate halts were added at Jessie Road and Albert Road (the latter was sometimes referred to as East Southsea, and was the one near The Festing). By now the line was facing increasing competition from trams, and it closed just after the outbreak of the First World War in 1914. You can still make out the route on a map: Francis Avenue and Heidelberg Road that curve off Goldsmith Road on the south-east side of Fratton Station are following it roughly, then Bath Road does the same.

The other pub is the Northcote Hotel not far to the north-west at the junction of Francis Avenue and Northcote Road. The Northcote after whom road and pub were named was James Northcote (1746–1831), an artist and writer who spent time in Portsmouth in the 1770s earning money to further his studies by painting the portraits of local people. The hotel was built in 1896, and so actually predates the station it later served.

Commemorated Soldiers

Between The Duke of Devonshire and The Bold Forester, Lawrence Road heads north from Albert Road towards Fratton. It is quite a major thoroughfare and there are several pubs along it. The first, as you head up the road and a few hundred yards on the left, is The Lawrence Arms. It is another of those cases where the pub and road bear the same name, and you wonder which came first – in this case the road seems the obvious candidate since it would have been important for the initial development of the area. The pub's sign has the coat of arms of the Lawrence family (including the motto 'Be ready'), but it is not known for certain which member of the family it is named after. One possibility is Sir Henry Lawrence, a soldier who died in 1857 in the Siege of Lucknow, during what was once called the Indian Mutiny and is now seen as the Indian Rebellion. Another possibility is a plain Henry Lawrence, a local builder who worked on the early development of this area.

The possibility that it is named after the soldier is strengthened by there being another pub named after a soldier killed in the rebellion not far away. As Lawrence Road continues north, it reaches a mini-roundabout and joins Fawcett Road, which has also run north from Albert Road and then bent around to the west (passing another pub called The Golden Eagle on the way). There is a similar case of road and pub bearing the same name here, as by the roundabout there is The Fawcett Inn. The pub, and presumably the road, is named after a Lieutenant Alexander Fawcett who was killed at a place called Bejapore on 5 September 1858 while leading his men against the enemy.

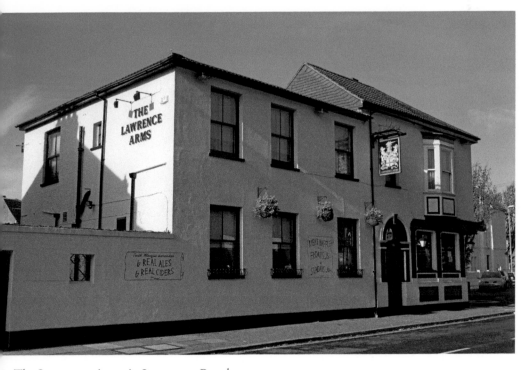

The Lawrence Arms in Lawrence Road.

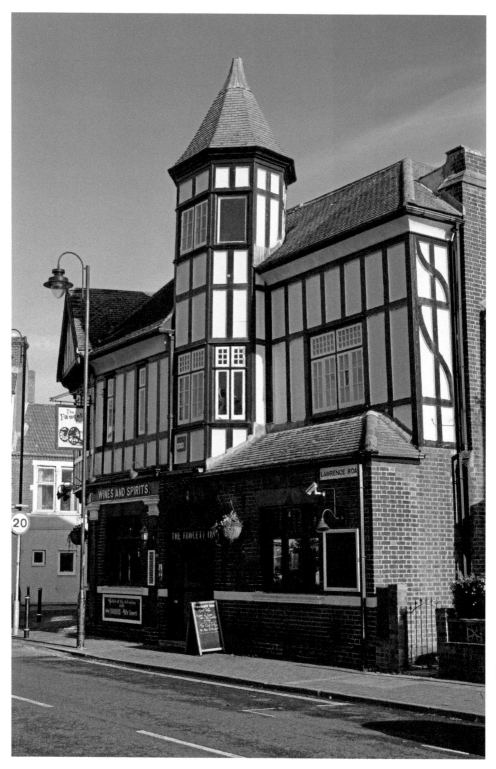

The Fawcett Inn with its 'witch's hat.'

The pub itself was the work of A. H. Bone and was built in 1886. Like several other Portsmouth pubs built around this time, it has a small tower of the type called a 'witch's hat' after its shape. The building was constructed in a style sometimes called 'Brewers' Tudor', with the upper floor half-timbered (as on many Tudor buildings) and brickwork on the ground floor. The name of the company for whom Bone designed the building, Brickwoods, together with some of their products that were on offer inside, is still displayed on the fascia.

Though the pub is clearly named after a real person, the name of course includes the pun of 'force it in'. The builders of the pub must have been aware of the pun, which could have been avoided easily by calling the place the 'Fawcett Arms' or some such, so its looks like we have here some Victorians with a good sense of humour! The pun is perhaps used in the pub's sign, which shows a soldier and a cannon – did he have to force the cannonball into the cannon?

Then a little way up Fawcett Road there is The Red White & Blue, which was named after the colours of the Union flag and dates from the nineteenth century. The pub's sign displays that flag and a sailing ship, no doubt once more celebrating Portsmouth's historic connection with the Royal Navy.

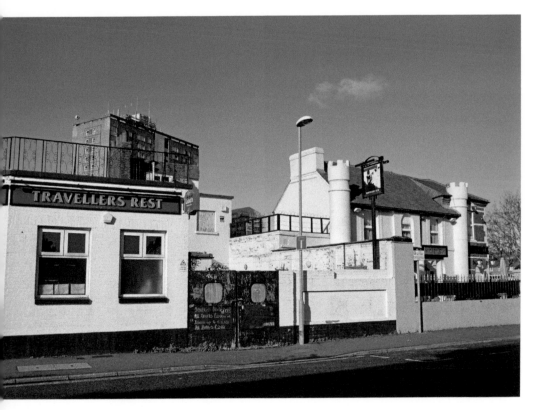

On the left, the closed Travellers Rest, with The Castle on the right. The latter is now an oasis in something of a pub desert. And in true 'castle' style it has turrets with crenellations on the top.

An Isolated Survival

And now for a pub that doesn't really fit into any of the chapters of this book easily simply because it is some distance from other hostelries, making this as a good a place as any to describe it. This is The Castle in Somers Road in Somerstown, which can be glimpsed from Winston Churchill Avenue as you travel from the Fratton end into the city. There were once lots of pubs here, but whereas in some areas like Albert Road in Southsea a fair number survive today, The Castle is the only survivor. The amount of redevelopment hereabouts, including Winston Churchill Avenue dividing Somers Road in two, can't have helped much in this regard, and neither are there shops or the like to attract people to the area. And as if to emphasise the point, there is a former pub called the Travellers Rest next door to The Castle. So, when all is said and done, this nineteenth-century pub has done extremely well to stay in business, and indeed it underwent a major and successful refurbishment a few years ago.

Eastney and Milton

Next we head east from Southsea to cover the areas occupying the south-eastern part of Portsea Island. Eastney is very much in the corner of the Island, and was a separate hamlet until Portsmouth expanded here towards the end of the nineteenth century.

The Eastney Tavern

This is the most southerly pub in the area, and it literally curves around the inside of a bend in Cromwell Road, the main route inland from the eastern part of the Esplanade. Outside it has an attractive blue-and-white colour scheme, and though one well-known feature encourages visitors, there is a lot more to see inside.

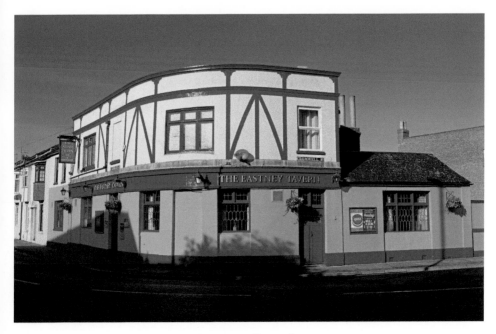

The Eastney Tavern curves around Cromwell Road.

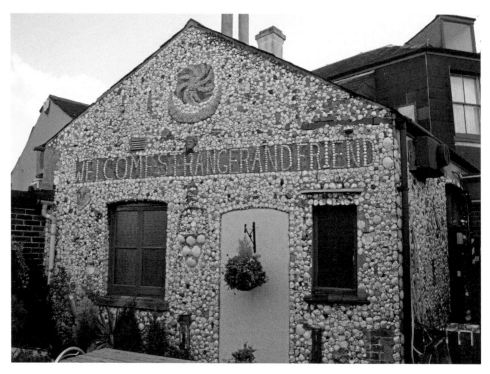

Above: The famous seashell wall in the garden of the Eastney Tavern, with the inscription 'Welcome Stranger And Friend'.

Below: Traditional tiling survives above the bar of the Eastney Tavern.

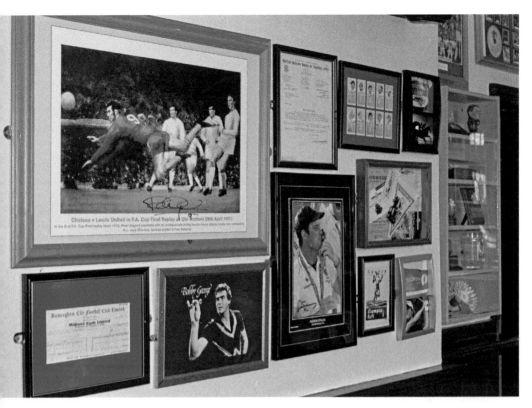

Sporting memorabilia inside the Eastney Tavern. Peter Osgood scores for Chelsea against Leeds United in the 1970 FA Cup final replay in the painting in the upper left, with darts player Bobby George and cricketer Andrew Strauss below and to the right.

That feature is in the pub garden, and is usually called the seashell wall. It is not actually made of seashells, just decorated with them. The phrase 'Welcome Stranger and Friend' is spelled out with shells – exactly the attitude you hope for when visiting a pub – and there are other patterns among the shells, as well as a small carved head that must have come from some other building once upon a time.

The pub also has a traditional-style interior, but what I found most striking is the wide range of sporting memorabilia. Many local pubs display their allegiance to Portsmouth FC, but many sports as well as football are represented here, with pictures, some signed, as well as shirts and various other artefacts from the world of rugby, darts, cricket, athletics, boxing and so on. There are also framed letters and a picture relating to the construction of the seashell wall, with a correspondent explaining that she came from Cardiff every year to see the wall, which was built by her grandfather.

Serving the Royal Marines

The Eastney Tavern was one of a group that catered not only for the residents of the new streets built in the area, but also for the occupants of the adjacent Royal Marine

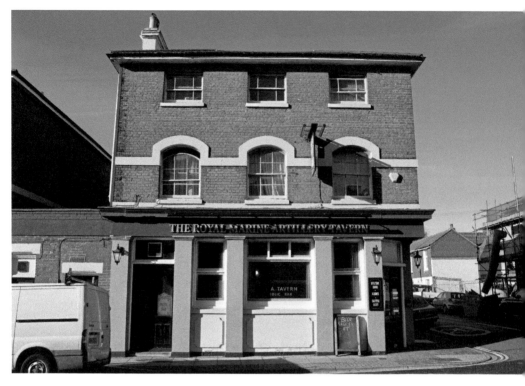

No doubt about who was being invited in! The Royal Marine Artillery Tavern as it would be seen by those leaving the barracks.

Barracks, and indeed two pubs here refer to the Marines in their names – a great way to attract loyalty in one's customers!

At a corner a short way up Cromwell Road there is The Royal Marine Artillery Tavern, an imposing three-storey Victorian building. It and another pub on the other corner of this junction called the Eastney Cellars, closed at present, were directly opposite the main entrance to the barracks. They are very reminiscent of the pubs on The Hard that are situated just outside the Naval Dockyard entrance, and many of which also had names linked to the profession of their intended customers.

The Three Marines is round the corner along Highland Road. Like the houses nearby, it was built in the late nineteenth century. It was originally called the Royal Oak, a common pub name that is often associated with the story of Charles II hiding in an oak tree while escaping from pursuing Parliamentarian forces that had defeated him at the Battle of Worcester in 1651. It changed to its present name, probably in the 1950s, to reflect its proximity to the barracks. The pub has a hanging sign depicting three marines, each in the uniform of a different century from the seventeenth to the nineteenth, and another on the wall around the corner that shows three more marines of different rank from the late eighteenth century. The hanging sign also has the Royal Marines' Latin motto '*Per Mare Per Terram*', which means 'By Sea, By Land' and dates from the eighteenth century.

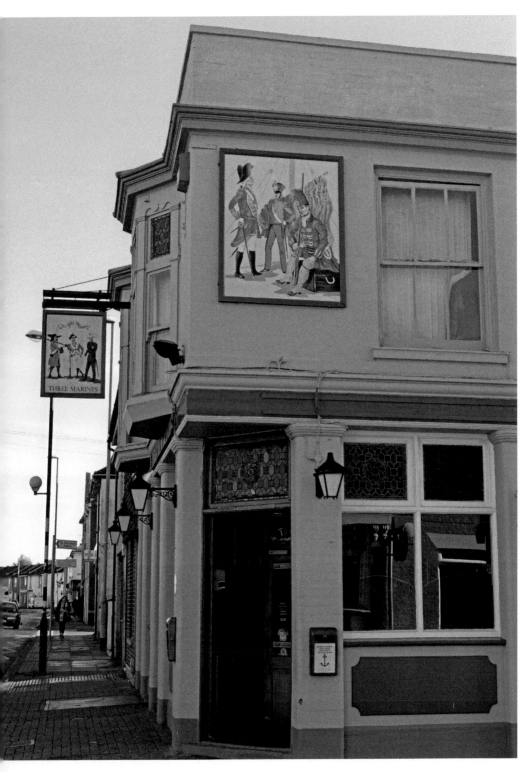

The two signs of the Three Marines.

A Good Story, But...

Going back on Highland Road towards the mini-roundabout where it joins Cromwell Road and Eastney Road, we pass the Sir Lion of Beef. It was constructed around the same time as The Three Marines and was originally called the Cambridge Arms. Up to the 1990s it was another Eldridge Pope pub, and before that in 1977 it changed its name.

This plays on one of those historical stories that surprises us when we find that it isn't true. This one goes along the lines that a king once enjoyed a loin of beef so much that afterwards he knighted it, so that it became 'Sir Loin'. One version says that the king in question was James I, and that the incident happened at a place called Hoghton Tower in Lancashire in 1617. Perhaps James I did make a joke of this at the time, but the name 'sirloin' existed long before for this cut of meat, coming from Old French and meaning 'above the loin'.

Heading north from the mini-roundabout up Eastney Road we next encounter the Fort Cumberland Arms, the name of which is another that reflects local military connections. This one comes from the fort built in the mid-eighteenth century by the Duke of Cumberland on the south-east corner of Portsea Island to protect the entrance to Langstone Harbour and as additional protection for Portsmouth Harbour.

Along Locksway Road to Langstone Harbour

A few hundred yards north again, Locksway Road heads off east towards Langstone Harbour. It is well worth heading down it to find three pubs as well as the fine views of Langstone Harbour and an unusual piece of local history. The first of the three is partway along the road.

'The Old House at Home' was the name of an early nineteenth-century poem, the work of one Thomas Haynes Bayly. In the 1830s it was set to music and the song became popular among soldiers on service abroad who were feeling homesick. It must have been chosen as the name of a pub because it was inviting, suggesting to potential customers that here was a homely place where they could enjoy a drink in comfort.

The other two are across the road from each other at the end of the long straight stretch of Locksway Road. On the north side of the road there is the Old Oyster House, as it is generally known, although 'Milton Locks' is added to the end of this in the name displayed on the pub itself.

The name of the establishment may well come from the farming of oysters in the adjacent part of Langstone Harbour. The building, or rather its predecessor, could have been the home of the owner of this business. The present building only dates from 1930, being designed by A. E. Cogswell. In this case he adopted something of a Georgian style, with a symmetrical design and ornate doorways. Its predecessor was somewhat smaller and looked like an ordinary cottage.

The pub on the other side of the road faces out onto Eastney Lake, an inlet of Langstone Harbour and an area where many local people whose homes were destroyed by wartime bombing lived in houseboats, in many cases into the 1960s. This pub is called The Thatched House, which is part of the Fayre & Square chain. It is relatively modern building with no thatched roof, but the original nineteenth-century pub presumably had one. The pub has an outside area of seating pleasantly close to the waterside.

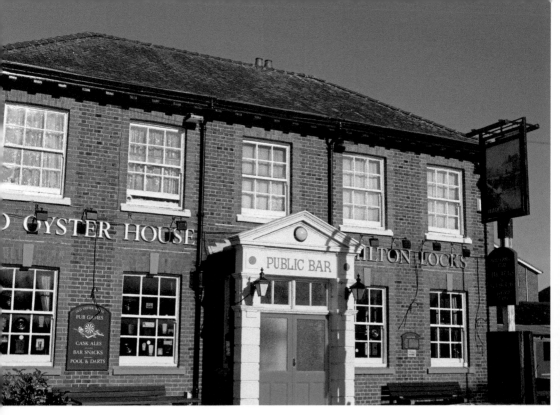

Above: The whole front of the pub is needed to display the full title of the Old Oyster House Milton Locks.

Below: Looking across Eastney Lake from the south side, The Thatched House is the prominent building with the largely white frontage. The tower block beyond is part of the University of Portsmouth's Langstone Campus.

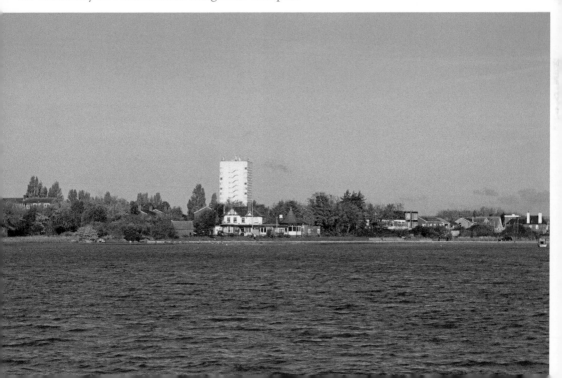

Milton Sea Lock opening into Langstone Harbour.

If you visit these establishments in good weather, it will be a shame not just to enjoy the view across Langstone Harbour, but also the nearby sea lock, which can be reached along a footpath that leaves Locksway Road by the two pubs, or directly from The Thatched House. This is the only surviving section of the Portsea Canal, which ran across to Landport. The canal was part of a larger scheme, the Portsmouth and Arundel Canal, which was intended to allow vessels to transport goods between Portsmouth and London without having to venture into open sea. The need to avoid the sea came about because of the danger of attack from French ships during the Napoleonic Wars. The scheme opened in the 1820s, and though a fine idea in theory, in practice there were many difficulties, including the leaky Portsea Canal contaminating local water supplies, so it did not last long. And the reason why the Old Oyster House has 'Milton Locks' in the plural as part of its name is that there was originally a second lock by this pub, which has been long demolished and filled in.

Here's another fact (or is it fiction?) about the area. Beyond this pair of pubs the road bends and runs for a short distance with houses that face onto Langstone Harbour on the right side. One of these was the home of Detective Inspector Joe Faraday, the main character in the series of Portsmouth-based police procedural novels written by Graham Hurley.

Historic Milton

Going back to the main road and heading up what is now called Milton Road we reach the location of the original village of Milton. Here on the left there is the Milton Arms, very much a village pub before Portsmouth engulfed the area. Among the historic features that survive include an old barn that now forms one of the pub rooms. And just past a junction there is another pub, the Brewers Arms, which is another long-established hostelry.

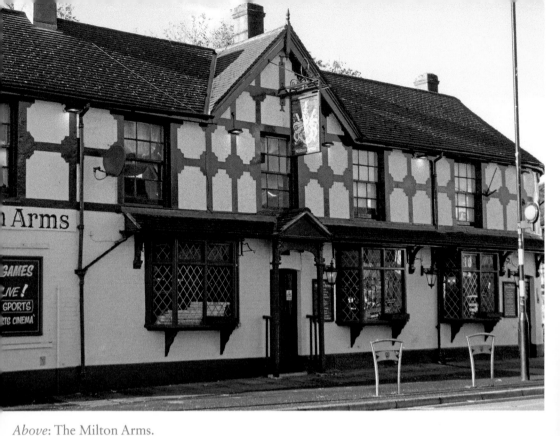

Above: The Milton Arms.

Below: The Brewers Arms.

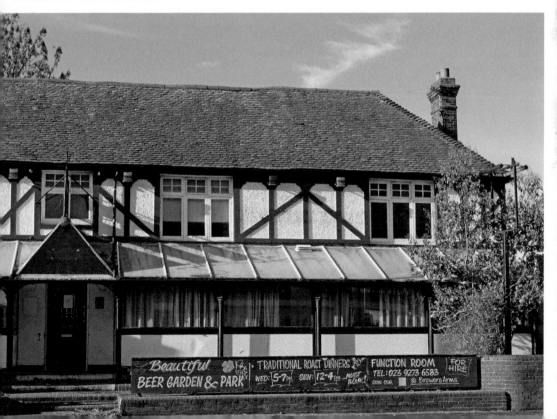

Named After Some Lovely Countryside

Meon Road heads east off Milton Road opposite the Milton Arms, running parallel with Locksway Road's western end. Along here there is the Meon Valley pub, which was built in 1930. Presumably the road was named first, after the River Meon, which rises on the south side of the South Downs a few miles west of Petersfield and then heads roughly south-west for around 20 miles before flowing into the Solent at Titchfield Haven to the west of Gosport. It is unusual for a pub to be named after a geographical area, but 'Meon Valley' was an obvious choice in this road, especially as this is a particularly attractive part of Hampshire and the name might remind potential customers of happy day trips into the countryside.

Ahead Of Its Time

Back on Milton Road and continuing north, there is a set of traffic lights from where we turn right into Velder Avenue. At another junction this turns north-east to run past Milton Common and become the main easterly road off Portsea Island, and at that junction there is a large and distinctive pub, the Good Companion.

The Good Companion occupies a sizeable building.

It was opened by Brickwoods in 1938 and had been built on what was then open land given to the brewery by Portsmouth Corporation in exchange for a site in Landport. This land must have been part of Milton Common. There was a concept behind the construction of this pub that seems surprisingly modern, as Brickwoods sought to get away from the small cosy pub of previous generations that was aimed only at drinkers of alcohol, and was often highly decorated to attract them. Instead at this new establishment, and another we will see shortly, they wanted a spacious building where families could come for a meal and feel as comfortable washing it down with coffee as with beer, which is of course how many pubs view their clienteles today.

The development of the surrounding area in the 1970s and 1980s has removed the Good Companion's open setting, but the building is still a landmark as you head along Velder Avenue.

Fratton Road and its Northward Continuations

In this chapter we shift over to the middle part of Portsea and follow the major routeway that runs up through Fratton, Kingston and North End, and where there are many pubs to be seen. Most of these pubs were built as part of the expanding suburbs, though there is the odd exception.

Fratton Road runs north from the roundabout by Fratton railway station. It changes its name to Kingston Road as it moves into that area, and further on it becomes London Road, one of the main routes to the mainland. Sections of it are lined with shops, and are effectively the High Streets for Fratton, Kingston and North End.

Sections of the route have so many surviving pubs, as well as other buildings that can still be recognised as having been pubs once, that this is one of those parts of the city where you get a feel of what much of Portsmouth was like until a few decades ago, when just about every street had a pub, usually on a corner. In such locations, pub crawls involved very little exercise indeed!

Commemorating the Old Place

Having said how many pubs there are along this road, I have to admit that you go some way before you reach the first of these, the Froddington Arms. In the nineteenth century it began as The Plough & Spade, then the name went upmarket and became The Swiss Gardens. Around the end of that century it changed again to its present one, which uses Fratton's original name, dating from the Middle Ages. It sounds like whoever chose this name had an interest in local history.

The Froddington Arms is on the end of a street, and across the road there is another junction. On one corner here a former pub called the Magpie can be seen, while on the other there is the John Jacques, which now belongs to Wetherspoons. The building previously belonged to the Portsea Island Mutual Co-operative Society, of which Baron John Jacques was the chief executive from 1945 until 1965. He was later appointed to the House of Lords, representing the Co-operative Party, which operates in partnership with the Labour Party.

The Froddington Arms, dappled in sunlight.

The next pub is a few hundred yards along on the same side. But before we get there, a former pub on the left deserves an honourable mention. This was called The Guardsman and was in a timber-framed building that dates from the seventeenth century, making it two centuries older than the expansion of Portsmouth into the area. It only closed a few years ago and may well have been Portsmouth's oldest pub when in business.

A New-Fangled Invention?

To go on to that next surviving pub, I must admit to having been fascinated with the name ever since I first saw it – The Electric Arms. At first this seems an odd choice for the name of a pub – electricity is something we take so much for granted. The pub's sign reflects this modern view, showing a workman-like (and jolly) electrician. Then you think back to the early uses of electricity in the late nineteenth century when it transformed people's lives both in the home and in public, bringing in efficient lighting, heating and so on – at this time electricity was cutting-edge stuff with new applications coming in all the time, rather like computing and the internet over the last couple of decades – and the name makes more sense. So it then comes as a surprise to find that the name dates from a rebuild in 1924, by which time electricity was in common use. One theory is that the name is linked to the electric trams that once ran up and down

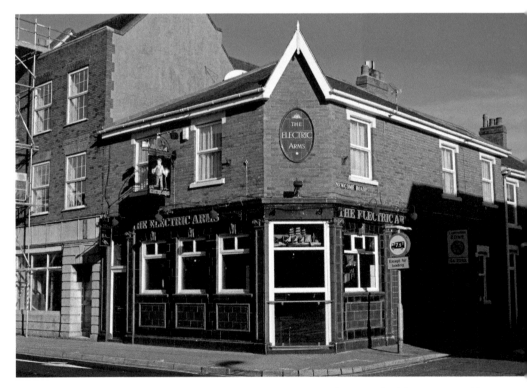

The Electric Arms – the electrician depicted on the pub sign is holding a pint of beer in one hand and an electric cable in the other.

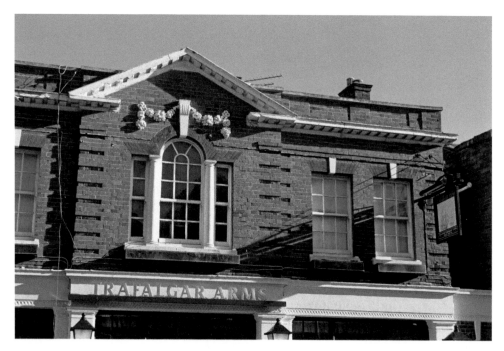

Georgian-style decoration on the Trafalgar Arms.

Fratton Road. The rebuilding was the work of A. E. Cogswell, with the new Electric Arms replacing two hostelries that had occupied the site before – the Fratton Cellars and the Old House at Home.

Further on there is the Trafalgar Arms, named after Admiral Nelson's great victory of 1805, and built by Cogswell in 1926 in a Georgian style.

A Couple of Diversions

There is then a gap of several hundred yards, during which we pass Kingston Church, the tower of which is still one of the great landmarks of central Portsea Island. A short diversion westward by the church into Church Road takes us to the Jameson Arms. The pub's sign shows the coat of arms of the Jameson family, including their motto '*Sine metu*', which is Latin for 'without fear'. The present building was designed by A. E. Cogswell and dates from 1934, so it must have been one of his last works.

On the north side of Kingston Church, St Mary's Road runs east towards Milton Road. At some distance along it there is a pub called The Battle of Minden, named after a conflict during the Seven Years' War, which ran from 1756 until 1763 and involved all the major countries of Europe. In this particular battle, fought in Germany, an Anglo-German army defeated a French one.

The pub itself was rebuilt in 1946 after being destroyed by wartime bombing. It is said to be the only pub in the country with this name. You might say 'not surprisingly' considering how obscure that battle is to us today, but people were still very familiar with its name when this pub was first built, a century or so after the battle occurred. As

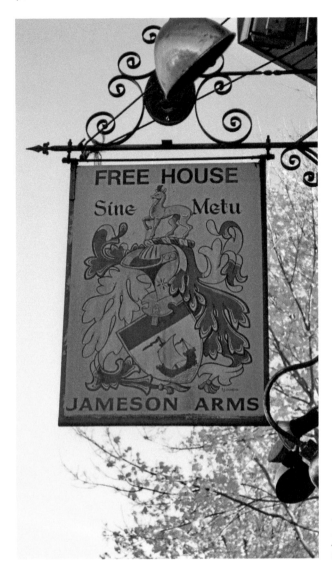

The coat of arms of the Jameson family on the sign of the Jameson Arms.

the Palmerston forts demonstrate, the nineteenth century was a time when conflict with France was on people's minds in Portsmouth as it was elsewhere in the country. Indeed there was also a coaching establishment in Hilsea with this same name at one time.

Another Witch's Hat

Back in Fratton Road, we finally reach a very striking pub called The Florist on the right. This is one of our friend Cogswell's best works, dating from 1924, with another of the distinctive 'witch's hats' above a half-timbered structure. And after some of the rather complicated explanations we find for the names of pubs, it is pleasantly reassuring to learn that this one got its name simply because there was a nursery nearby that grew flowers.

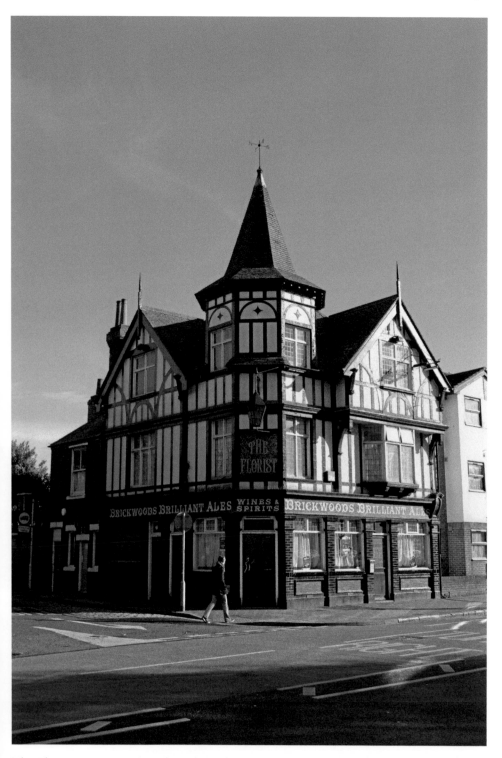

The Florist in Fratton Road, with its distinctive 'witch's hat' tower, similar to that of The Seagull on Spice Island and the Fawcett Inn, both pictured earlier.

A Legend

After another long gap, during which Fratton Road becomes Kingston Road, we find what may be Cogswell's next work. This is The George & Dragon, which he rebuilt in the year after he worked on The Florist. It looks like Cogswell still liked half-timber work as he used it here, although only at first floor level. The ground floor is covered with glazed brickwork, and in between 'Brickwood & Co.'s Brilliant Ales' is spelled out in mosaic tiles.

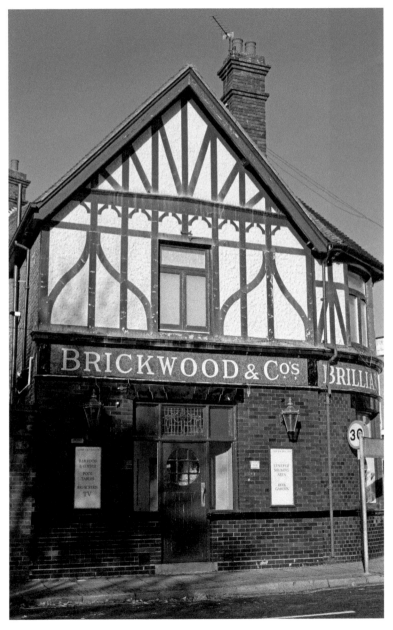

The side of The George & Dragon, showing the half-timbering, the mosaic and the glazed brickwork.

As for the origin of the pub's name, the story of St George killing the dragon is one of those that every schoolchild was taught at one time, but it has become less well known recently, at least partly because the inclusion of the dragon makes it 'mythological'. It is probable that St George was a real person, probably from modern-day Turkey and a soldier in the Roman army who was put to death around AD 300 for refusing to renounce his Christian beliefs. Like many saints, though, stories grew up around him. This one goes that the citizens of a certain town had to sacrifice one of their maidens every day to a dragon, then one day a princess is chosen for this. St George turns up in time to slay the dragon and save the princess, and the grateful townsfolk convert to Christianity as a result. We are not supposed to ask whether George would have bothered if the maiden in question had been a mere ordinary citizen.

Queens Road heads off on the right a few yards further along, and on a corner a short distance along here there is another pub whose name is linked to the road it is in. This is what has long been called The British Queen, though on the outside it is now named simply the BQ. Above the door there is an image of Queen Victoria, after whom both road and pub undoubtedly were originally named.

And The Pubs Just Keep On Coming

Going back to Kingston Road and continuing north, we find The Blue Anchor opposite the junction with Kingston Crescent (beyond which Kingston Road becomes London Road, the original main route from Portsmouth to the mainland). Bearing a good name for a Portsmouth pub, it is painted appropriately and decorated with anchors and ship's wheels. Unfortunately though, the pub has shrunk in size on two occasions. The original building was destroyed by a bomb on 11 July 1940, though luckily the landlord emerged unscathed from the ruins – it was then rebuilt as a single-storey building. Then when it reopened in 2012 following a closure of two years, it only occupied about two-thirds of this structure.

Across the road a few yards further on there are two pubs next to each other. The first is now called simply The Tap. It was built in the nineteenth century as the North Pole, which closed in the 1950s. It reopened in the 1980s as the Brewery Tap, as it served the products of the Southsea Brewery, which was in a nearby street. The brewery has closed, but the pub retains the memory in its shortened name.

Next door there is what I believe to be Portsmouth's only pub in a converted church (supporters of the nineteenth-century temperance movement must be rolling in their graves!). This was the North End Baptist Church, then after this went into disuse the building was converted into a pub called the Lanyard; a good nautical name, for one of its meanings is a piece of rigging used to secure or lower an object. After a period of closure, the pub reopened as The Grapes in 2015.

Further on and back across the road there is another Wetherspoons, this one being called The Sir John Baker. It is situated in premises that once belonged to a bank and is named after a North End man who lived nearby. He lived from 1828 to 1909, and was known as Honest John, being twice mayor of Portsmouth in the 1870s and later serving as one of Portsmouth's two Members of Parliament, representing the Liberal Party.

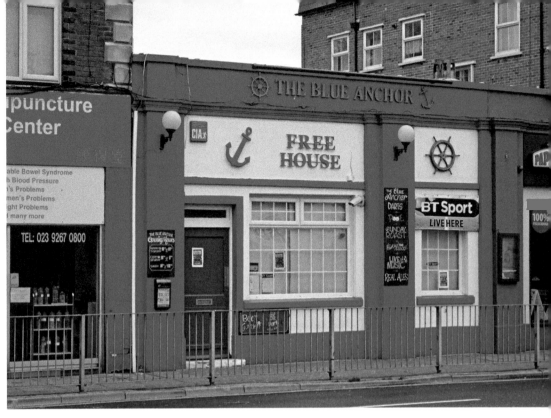

Above: The Blue Anchor, which formerly also occupied the green-painted building to the right.

Below: The Tap, advertising that it is undergoing a refurbishment and will need staff when it reopens, and The Grapes.

The Final Three

Back across on the west side of the road there is Thatcher's, which has had this name since a major and successful refurbishment in 2002. Before that it shared the name of one of the pubs down Locksway Road – The Thatched House. So again this probably had a thatched roof when it was built, probably in the mid-nineteenth century.

Crossing back and moving on we find The Clarence, named after the Duke of Clarence, who became William IV between 1830 and 1837 and was the uncle of Queen Victoria. He had been Admiral of the Fleet while still only a duke, which undoubtedly explains why the pub was named after him. The establishment used to be called The Clarence Gardens and was rebuilt in 1937 to a design of Arthur Cogswell's, who had died three years previously.

Crossing once more and past the mini-roundabout there is the final pub in this group, and one dating from the early part of Cogswell's career. This is The Fountains, rebuilt to his design in 1895 and perhaps so named because of a nearby well. The earlier building had been a coaching inn.

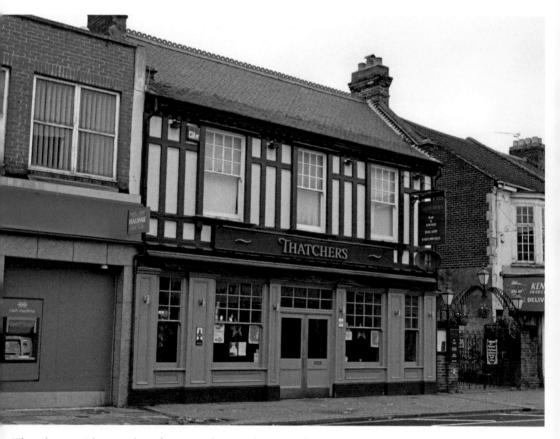

Thatcher's with a modern frontage designed in a traditional style.

Northern Portsea Island

Now to cover the remaining part of Portsea Island – the 'top end' on the map. Pubs here are rather more scattered than elsewhere, probably reflecting the fact that much of the area was developed quite late on, when a pub on every street corner was no longer considered a necessity, and also that a lot of land here was given over to leisure and industry rather than housing.

Starting On the West Side

Going back to the top end of Landport and heading north we pass The Royal, which took its name from the former hospital across the road, and then we encounter a closed pub called the Air Balloon. This may seem an odd name for a pub today, but back in the day when such balloons were a great novelty and one was launched near this spot, it was thought perfectly appropriate to then name a pub to mark the occasion.

Just past here there is Rudmore roundabout, beside which is the Admiral Drake. Named of course after Sir Francis who sailed around the world in the time of Elizabeth I, the great man's portrait is on the front of the pub. The pub itself was rebuilt in 1936. And close by in Kingston Crescent the large Travelodge has a pub called the Sovereigns in its ground floor.

A Lone Standout

The old harbourside area called Rudmore lies west of the roundabout and on the north side of the Continental Ferry Port, and has been largely swallowed up by the associated infrastructure. There is one very notable exception – The Ship & Castle pub. I think the closest I have been to wanting to hug a pub and say 'well done!' was after seeing this pub and its location. It is a traditional-style Portsmouth pub surrounded by much more modern and larger buildings, but the point is that it is still hanging on in there! It was once a waterside pub like its namesake down on The Hard, but land reclamation in this area has made an enormous difference, so that what was once shoreline is now concrete. You might find it a little difficult to get to the place, but it is in a worthwhile cause!

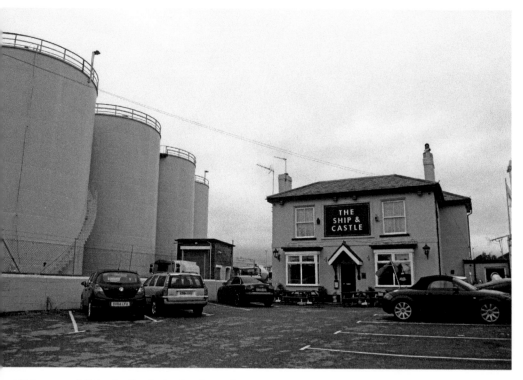

This second Ship & Castle is clearly no longer a waterside pub!

Names That Are Not What They Seem

Further on, Stamshaw occupies a northwestern corner of Portsea Island to the north of the Continental Ferry Port. The main road down the western side of the island divides for a while here, so that traffic going south uses Stamshaw Road and that going north runs along Twyford Avenue. In Stamshaw Road we find two pubs dating from the 1890s, and the origins of their names are not the obvious ones.

The Derby Tavern is at the southern end of the road. There are two obvious choices for the origin of this name – the city in the north Midlands and the horse race run at Epsom. The producer of the pub sign has gone for the latter interpretation – it shows racing horses. However, the pub is on the junction with Lower Derby Road, and further east Derby Road itself meets Monmouth Road and Cardiff Road, suggesting that the pub was named after the road, and that the developers of this area chose place names for their new thoroughfares. There is another possible explanation, though. To the south of Lower Derby Road there is Stanley Road, and the Stanley family have been earls of Derby for over 500 years (in the late nineteenth century one of them was Governor of Canada and donated the Stanley Cup that is still the prize in North America's premier ice hockey league). And on the other side, Ranelagh Road also bears an aristocratic name, so I prefer this third explanation.

The other pub is partway up Stamshaw Road. Today known as The Portland, it was originally The Portland Arms. And the most obvious source of the name is the Isle of

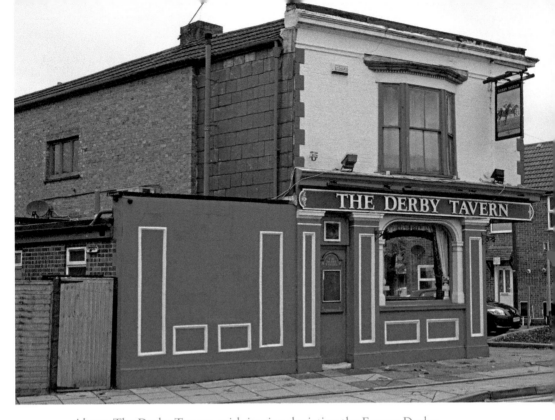

Above: The Derby Tavern, with its sign depicting the Epsom Derby.

Below: The Portland in Stamshaw Road extends across two buildings.

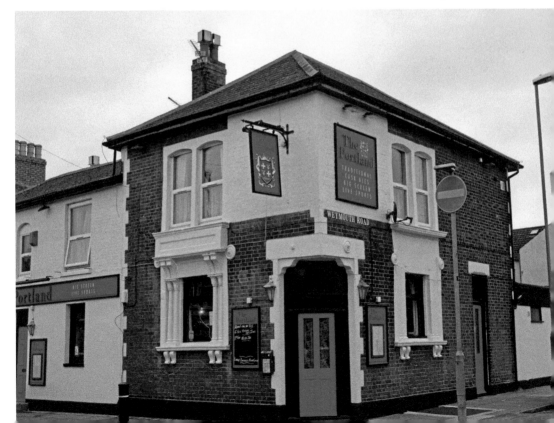

Portland on the Dorset coast some 50 miles west of here, especially as this is where much of the stone of Portsmouth's fortifications has come from. This is strengthened by the pub being on the junction with Weymouth Road, for the Isle of Portland is close to the seaside resort of Weymouth. However, in reality we are still in aristocratic territory, for the pub is named after one of the dukes of Portland, and the pub sign still bears a version of their coat of arms. The duke in question might have been the splendidly named William Henry Cavendish Cavendish-Bentinck (1738–1809), who was twice prime minister and who had a Hampshire connection in that before becoming duke his title had been Lord Titchfield.

A Yorkshire Prophetess

Twyford Avenue also has a pub – the Mother Shipton. The lady in question was a soothsayer who lived in Knaresborough in Yorkshire from around 1488 until 1561. Her real name was something like Ursula Southeil, but there is much uncertainty about this and other elements of her life and predictions because nothing was written down about her until some eighty years after her death. Today, Mother Shipton's Cave is a major tourist attraction in Knaresborough.

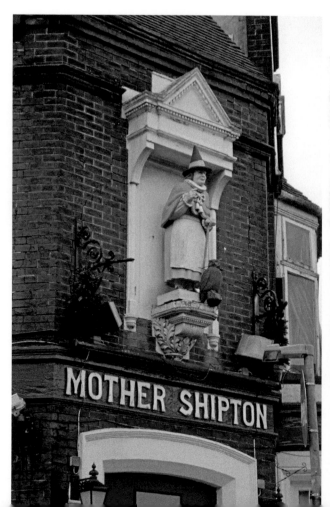

The figurine of Mother Shipton above the pub doorway.

How a pub in Portsmouth came to be named after Mother Shipton seems rather odd. However, it was apparently once a popular pub name, though this is the only one that still exists under this title (another survives in Knaresborough but has changed its name).

Above the doorway on the corner there is a carved figurine of Mother Shipton. It is the work of an Isle of Wight woodcarver called Norman Gaches, who made many such pieces for pubs, as well as figurines for ships and so on, and was set here in 1999 to replace an original one that had rotted. The original had been here since the pub was built in 1886, to the design of A. H. Bone. No images were made of the real Mother Shipton during her lifetime or by anyone who remembered her, so we cannot say that this figurine is lifelike, but it certainly fits the image we have of her, including the pointed witch's hat!

Green Posts

Some distance further up London Road than the group we looked at in the previous chapter, but still in North End, there is the Green Posts. Across the road from this pub there is a stone obelisk, which is set back from the pavement a little next to a car dealership. As a plaque on the obelisk explains, it was set up here in 1799 to mark the boundary of the borough of Portsmouth for those travelling on what was then the main road to and from the town. The plaque also points out that the obelisk became obsolete in 1832, when the borough's boundaries were extended. What may be important here is what marked the boundary before the obelisk was erected, and perhaps the name of the pub is a clue. For though the present building is only around a hundred years

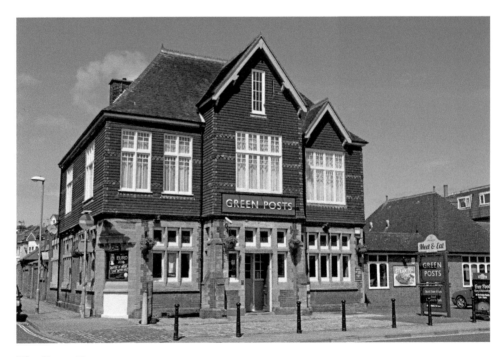

The Green Posts.

old, there has been a pub called the Green Posts here since the mid-eighteenth century, which means it predates the obelisk by some fifty or so years. While the pub's name could have originated simply because it had posts flanking its doorway that were painted green (in the same fashion, The Pembroke in Old Portsmouth was once called The Blue Posts), maybe it could have come from posts that originally marked the boundary before the obelisk was set up.

The obelisk opposite the Green Posts.

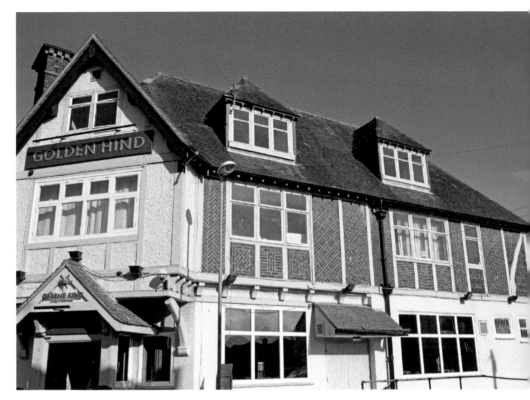

A side view of the Golden Hind, with nogging at first-floor level.

Nogging

The Golden Hind is in the northern part of Copnor Road. It was built in 1929 and is a fine example of a Portsmouth pub that was designed to be distinctive and attractive to potential customers. One particularly striking feature is the use of nogging, which consists of a timber framework infilled with bricks. You see this on quite a few historic cottages in rural Hampshire. In the past its use was simply a method of construction, but here it has been used as a decorative effect, with the bricks arranged in a variety of patterns.

The pub's original name was Ye Olde Inne, so perhaps the nogging was part of a plan to give it an historic feel. It was later renamed the Golden Hind after the vessel in which Sir Francis Drake sailed around the world.

More 1930s Hospitality

The Baffins is on Tangier Road opposite Baffins Pond, a natural feature (more like a small lake than a pond) that was retained as Portsmouth expanded into this area and which had a park laid out around it. The pub was built in 1937 by Brickwood's with the same philosophy behind it as the Good Companion – it was intended as a place where families could enjoy a meal together. The building itself is a fine piece of 1930s design, being shaped like an 'X' and having distinctive white courses among the brickwork.

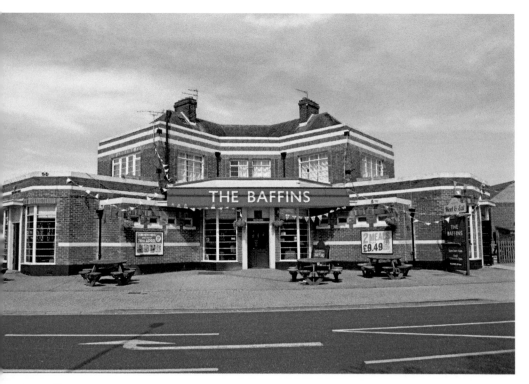

The Baffins.

Another Namesake

The Phoenix is halfway along Torrington Road, which heads east towards Copnor Road just after The Green Posts. It shares its name with the pub in Southsea, and in this case it was definitely not rebuilt after a fire. In fact it was built in 1937, originally as a hotel, at the same time as the housing around it on what had been one of the last undeveloped parts of Portsea Island.

Great Salterns

This is the large building that sits by a set of traffic lights on Eastern Road. It is especially prominent as you approach it from the south, and it commands fine views across Langstone Harbour.

Today, although the building is close to the seawall, its site looks like it has always been good solid ground. However, there has been extensive land reclamation on this part of Portsea's coast, beginning in the seventeenth century. You can pick up clues to this here and there, such as the marshy pond across the road in Southsea Golf Club (of which Great Salterns was the clubhouse at one time). In 1665 around 300 acres of land that was reclaimed in this area was given the name 'Great Salterns' from the shallow pools or salterns here in which seawater was evaporated to make salt.

A large house was built on the land not long afterwards, which was replaced by the present building around 1820. Maps show that the house was still almost on a

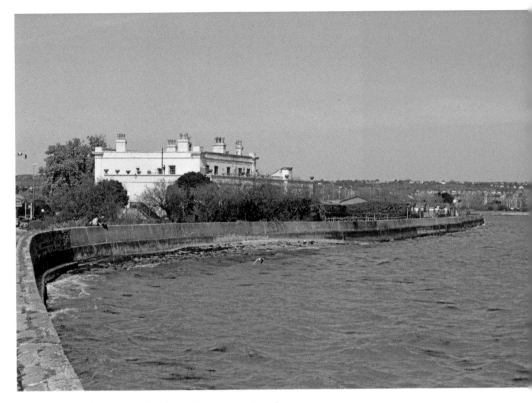

Great Salterns overlooking Langstone Harbour.

separate island – it was not until further reclamation works later in the nineteenth century that it became part of Portsea Island.

Portsea Island's Last Working Farm

The last rural part of Portsea Island to survive the expansion of Portsmouth was near the northern tip in Hilsea. The Island's last working farm was called Green Farm, then once its land was bought up for development, the farmhouse was converted into a Toby Carvery. This opened in 1992 and underwent further refurbishment later in the decade. The pub originally occupied the attractive timber-framed farmhouse that may well be over 500 years old, and a 200-year-old timber barn was also part of the pub complex. Then five or six years ago the farmhouse became part of a Travelodge, and today the Toby Carvery occupies the converted barn.

A Fit of Temper Preserved For Ever

The Coach & Horses is further on at the junction of Copnor Road and London Road. The name of the place comes from its location next to the main route off Portsea Island, which was long used by stagecoaches. The survival of a horse trough by the road outside the pub is perhaps connected with the watering of animals drawing these stagecoaches, as well as goods wagons and the like.

Evidence of the former barn in the Toby Carvery comes from the exposed old timberwork as well as the spacious interior.

This pub was originally situated a little to the north nearer to Portsbridge, but it was rebuilt here after a fire in 1870. In 1906 it was sold by its owner, the War Office, to Portsmouth United Breweries – then a year later the Liberal government changed the licensing laws and the pub lost a great deal of its value. The brewery's owner, Sir William Dupree of the brewery, was so angry at what he saw as double-dealing by the government that he had a mural painted on the side of the pub showing Sir Herbert Asquith (then the Chancellor of the Exchequer, and soon to be prime minister) as a highwayman. When the pub was rebuilt a quarter of a century later, two copies of this image were made in the form of painted tiles and can still be seen on the sides that face London Road and Copnor Road.

The wording above the image says 'The Coach and Horses A Tale of Highway Robbery' and the wording beneath gives a conversation between the coach driver (Dupree presumably) and the highwayman:

Asquith, Highwayman: 'Stand and Deliver!'
Coach-owner: 'But I have just paid your pal Haldane for this lot.'
Highwayman: 'Clever Haldane! He knew I was coming along, you may keep the Coach but hand over the Horses!'
'Haldane' refers to Viscount Haldane, who was Secretary of State for War when the pub changed hands.

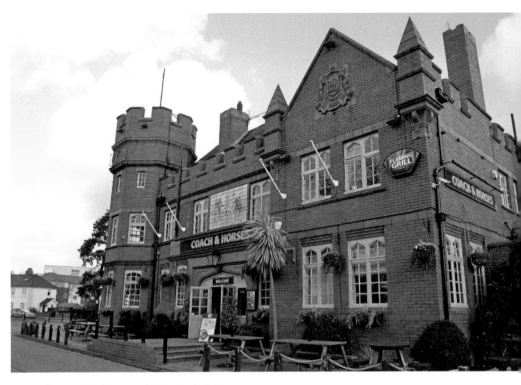

Above: The baronial Coach & Horses.

Below: Sir William Dupree vents his spleen!

This rebuilding was the work of our old friend A. E. Cogswell, and took place between 1929 and 1931. The previous building had looked like many another large roadside pubs, but Cogswell had been on holiday to Scotland, where he saw some of the mock castles that were built there in the nineteenth and early twentieth centuries as homes for the landed gentry. He decided to use their so-called 'baronial' style on this rebuild. The result is quite a striking landmark, particularly as you travel towards it from the mainland side.

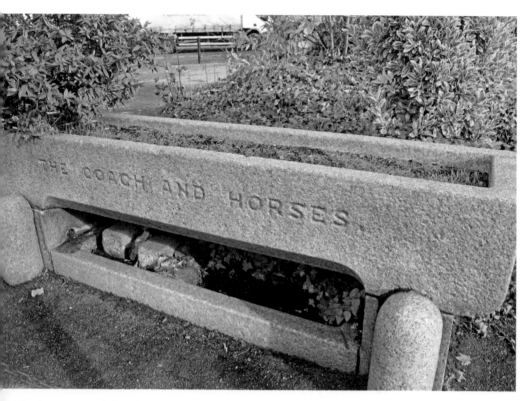

The horse trough has been appropriated for a spot of advertising.

The Mainland

By the 1920s, Portsmouth was well on the way to filling Portsea Island, and so it began to expand onto the mainland with the construction of housing estates in Cosham. The desperate need to rehouse people who lost their homes during the massive bombing raids on Portsmouth during the Second World War then led to a major expansion after the conflict, and the city soon extended out to Portsdown Hill. In doing so, it absorbed not only villages such as Cosham and Farlington, but also pubs that previously had a village or rural setting, similar to what had happened at Milton.

Changed Settings

The changes caused by Portsmouth's expansion is evident at the first two pubs we will look at, even in their names.

The first is in Southampton Road near the motorway junction and on the west side of Cosham, and not far from Port Solent (where there are three new pubs, by the way). It is a large twentieth-century pub called the Harbour Lights, which now belongs to the Beefeater chain and is sometimes simply referred to as the 'Beefeater'. The Harbour Lights name is a lovely relic of the pre-motorway days when the surroundings were much less developed and there were views across Portsmouth Harbour from here.

The other is The Portsbridge, a large building near the Portsbridge roundabout, in Portsmouth Road that leads to Cosham High Street. When originally built, it would have been named after the nearby bridge itself, which as an important crossing to Portsea Island would have been a very notable feature of the area. Today many people who use the roundabout on their way into the city probably don't even know they are going over to an island.

A Pub and a Milestone

There are two or three pubs in Cosham High Street, including The Red Lion Hotel by the road junction at the top. Though now bypassed by the A3, historically this was part of the main London to Portsmouth road, and the hotel would have benefited from trade along it.

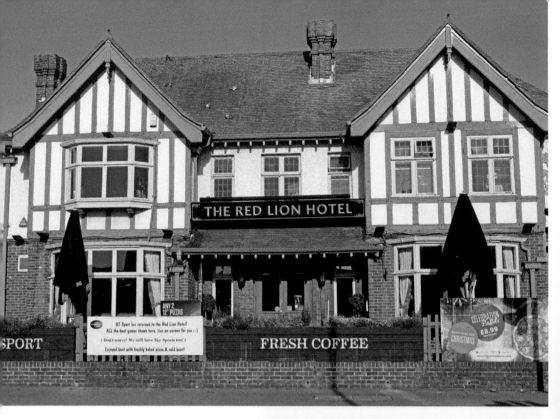

Above: The Red Lion Hotel in Cosham.

Right: The milestone beside The Red Lion Hotel.

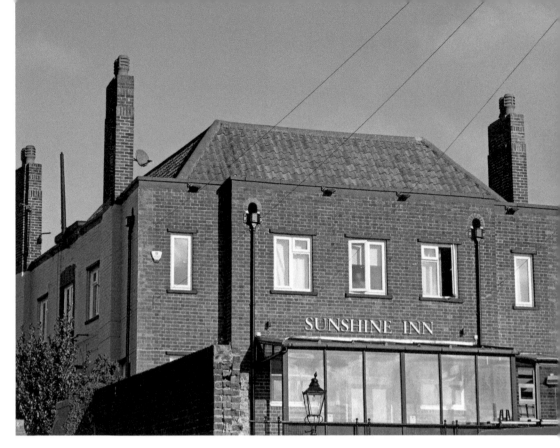
The Sunshine Inn, Farlington.

In London Road by the far corner of the Hotel there is a 200-year-old milestone. It tells us that we are 65 miles from London, 13 from Petersfield and 4 from Portsmouth. When it was first erected of course, Portsmouth was largely limited to the area within the defences, which we now call Old Portsmouth. This is not the only such milestone to survive – the next one south can still be seen by the roadside just north of the Coach & Horses back in Hilsea, for instance. On the Hilsea example, you can see the information in its original form, inscribed in the stone. The original inscription in Cosham must have worn away quite quickly as it has been replaced with an iron plate, which looks quite old in itself.

On Its Own
And then there is what must be Portsmouth's most remote pub, in that it is the furthest from any of the city's other establishments as well as being close to the Portsmouth boundary. This is the Sunshine Inn in Farlington, which is on the south side of Havant Road about a mile and a half east of The Red Lion in Cosham.

Portsdown Hill
And finally we climb Portsdown Hill for two hilltop pubs. As London Road heads north from the Red Lion Hotel, it is soon is joined by the main A3, which has

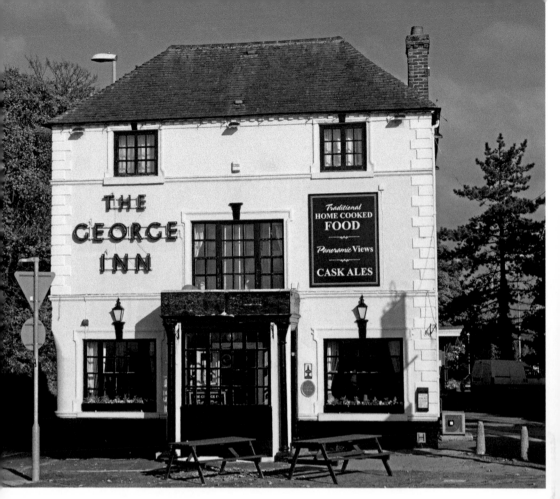

The George Inn waits to refresh travellers after their climb.

bypassed Cosham's High Street. At the top there is a junction with Portsdown Hill Road, and here we find The George Inn. As roadside inns go, this historic example was particularly well located, not only at a junction but also being able to offer refreshment to those who had just finished the climb, and with fine coastal views thrown in for good measure!

The building dates from the late eighteenth century and was originally separate cottages. These were called Milestone Cottages, undoubtedly because the next milestone from Portsmouth (now at a distance of 5 miles away) was located close by. So after the Coach & Horses in Hilsea and The Red Lion Hotel in Cosham, this is the third pub that was by a milestone, which seems rather more than a coincidence. When it became a pub, the place must have been renamed after the current monarch, either George III (who reigned from 1760 to 1820) or his son George IV (1820–30). The remains of the old fire station that served the village of Widley on the north side of Portsdown Hill can still be seen at the pub.

The Churchillian is a few hundred yards to the west along Portsdown Hill Road, opposite the main viewing car park and just before Fort Widley, one of the Palmerston

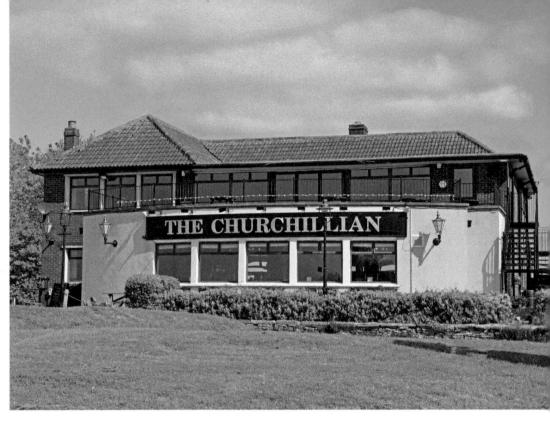

Above: The Churchillian.

Below: Looking inland from the car park behind The Churchillian, with the South Downs in the distance.

forts. It was built in 1964 and of course was named after Sir Winston, whose image adorns the pub sign. Apparently it was not named as a memorial to the great man, who was still living at the time (though he died in January of the following year). The pub's location was clearly chosen because it is on a hilltop with excellent views across the city and of the wider coastal area, but there are also excellent views inland across rural Hampshire.

Inside, there is a long room with large windows that allow you to enjoy the view of Portsmouth and the Isle of Wight beyond from your table (I should probably add 'weather permitting' at this point).

A Few Final Words

The pubs of Portsmouth are a varied and historic resource, and contribute a great deal to the character of the city. But they are also vulnerable to changing times, and it is very much a case of 'use them, or lose them'. Indeed, several times when researching this volume I saw pubs that had been in business until very recently but were now closed – it is to be hoped that as least some of these will reopen. So please remember that the pubs of Portsmouth are altering in various ways all the time (fortunately not just closing, but diversifying too), so things may be a little different when you explore them.

'Pubspotting' can be quite entertaining as you travel around the city. Their various designs usually enhance their neighbourhoods, and it can be fun to work out which other buildings were once pubs as well. You will also see that the number of surviving pubs varies considerably. Sometimes it is obvious why they are here, as they are intermingled with shops or nightspots that attract people to their area, or where they have views of the waterfront. For others, though, a pub's survival in a less obvious location has depended on owners who care and make an effort, and a local community that cares as well and supports their 'local'.

If this book helps the noble cause of keeping Portsmouth's pubs alive and well in any way, I will be very happy.

Bibliography

In writing this book I used a number of internet sites as sources of information, including some belonging to individual pubs. The 'Portsmouth Pubs' website was especially useful. I also used the following books:

Bardell, M., *Portsmouth: History and Guide* (Stroud: Tempus Publishing, 2001).

Brown, R., *The Pubs of Portsmouth From Old Photographs* (Stroud: Amberley Publishing, 2009).

Eley, P. and Riley, R. C., *The Demise of Demon Drink? Portsmouth Pubs 1900–1950* (Portsmouth: Portsmouth City Council, 1991).

Gates, W. G., *Illustrated History of Portsmouth* (Portsmouth: Charpentier and Co., 1900),

Gates, W. G., *Portsmouth Through the Centuries* (unbound copy in Portsmouth Library, 1931).

Pevsner, N., *The Buildings of England: Hampshire and the Isle of Wight* (London: Penguin, 1967).

Sadden, J., *Portsmouth: A Pocket Miscellany* (Stroud: The History Press, 2012).

Smith. J., *The Book of Hilsea: Gateway to Portsmouth* (Halsgrove: Tiverton, 2002).

Wallis, S., *Secret Portsmouth* (Stroud: Amberley Publishing, 2016).

Acknowledgements

The following people at pubs featured in this book were all especially welcoming and helpful: Paul Wickes at The Apsley House; Phill Butler of the Bridge Tavern; Josh Fry at The Coach & Horses; Hugo Teixeira and Kyle Hayward of The Churchillian; Chris Moon at the Eastney Tavern; Nikki Wilkinson and Karen of The George Hotel in Portsea; and Ian Clegg at the Toby Carvery in Hilsea. Jo West of Blackwell's bookshop also provided some very useful background information.

Though unconnected with the pub trade other than supporting it as I think we all should, Emily Preston and Louise Waller also provided much assistance.

And I found lots of useful information for this book in Portsmouth History Centre, which is located in the Central Library, and also in Portsmouth Museum.